TOMASZ RUT

BY ROLAND NAIRNSEY

FOREWORD BY TOMASZ RUT

TR

PARK WEST GALLERY

SOUTHFIELD, MICHIGAN

FIRST PUBLISHED IN THE UNITED STATES OF AMERICA IN 2006
PARK WEST GALLERY
ALBERT SCAGLIONE, PRESIDENT
29469 NORTHWESTERN SOUTHFIELD, MI 48034

PRODUCED BY MAC FINE ART
DESIGNED BY SUISSA DESIGN, HOLLYWOOD, FL
PRINTED AND BOUND IN CHINA

ISBN: 0-9742588-3-0

ALL WORKS BY TOMASZ RUT © TOMASZ RUT
FOREWORD BY TOMASZ RUT
ESSAY BY ROLAND NAIRNSEY
DIGITAL IMAGERY: GERALD R. BARKER

COVER IMAGE: **AD ULTRO**, 2002, 50 X 60 IN.

FRONTISPIECE: **IN FIDE**, 2001, 47 X 67 IN.

IMAGE OPPOSITE TO ESSAY ON PAGE 16: **ERUDITIS**, 2005, 32 X 50 IN.

CONTENTS

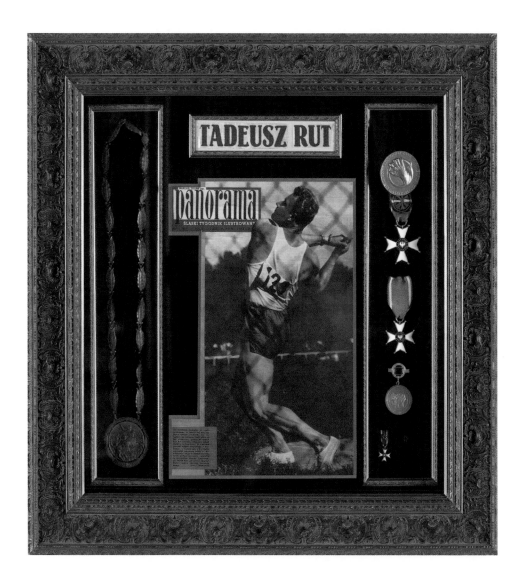

This book is dedicated to the memory of my Father.

ACKNOWLEDGMENTS

I would also like to give special thanks to the following people, for their
invaluable contributions that made it possible to create this book.

To my wife Anu, who is my angel and assists me in every aspect of my work and life.

To Albert and Marc Scaglione, for their vision which makes it all happen.

To Albert Molina, for his relentless pursuit of greatness.

To Richard and Mary Ann Cohen, for their integrity in the face of ever changing
circumstances, and to the entire staff of MAC Fine Art, for doing their best to make
my artwork available.

To Jerry Baker, for his unfathomable computer skills which made this book so beautiful.

To Roland Nairnsey, who is the living proof of kindness and tolerance, for his
faith and consistency.

To Jola Szyfter, for appreciation and listening.

To Tomasz Chrust, who has always modeled for me not only with his body but
also with his life.

To my beloved French Bulldog, Pork, who endures quietly countless hours with me
at the studio – being my only true witness – and makes it all fun.

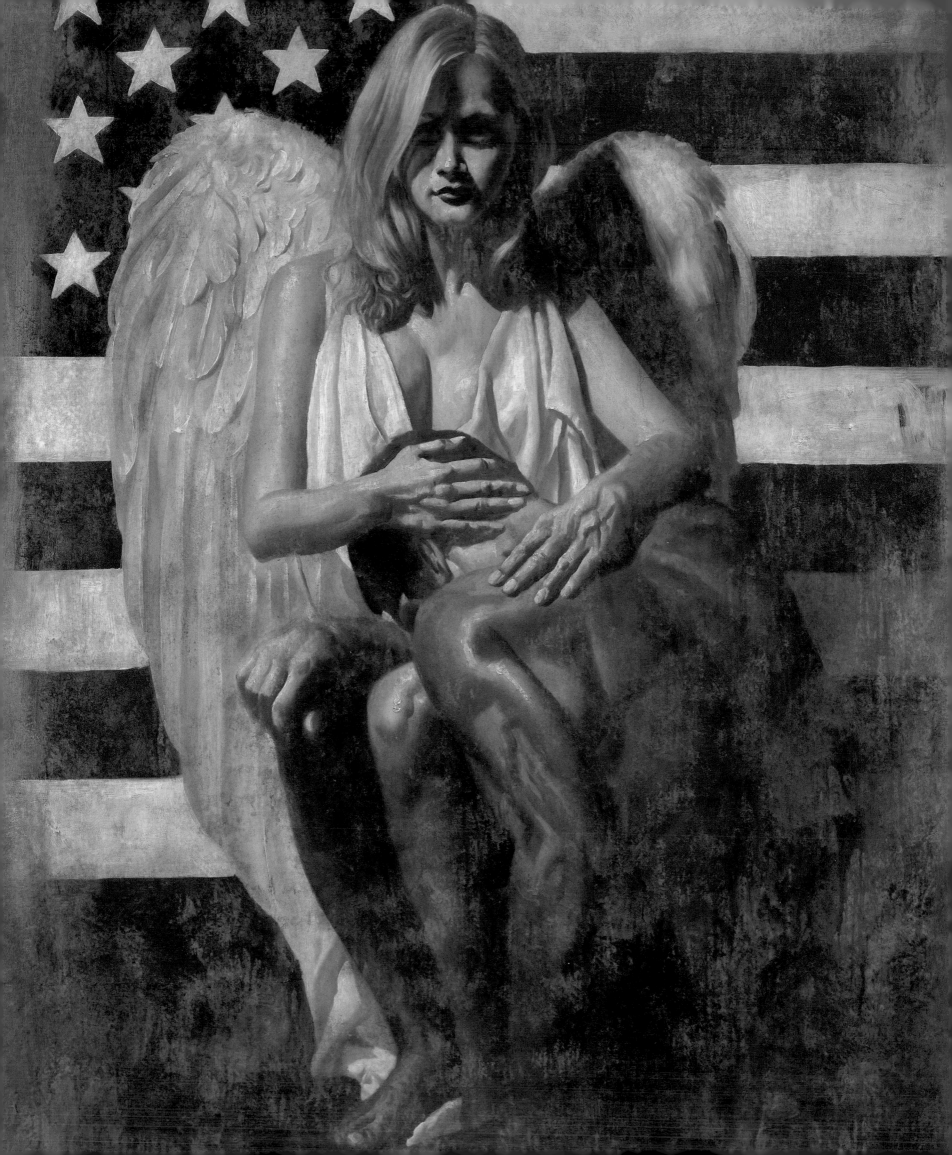

FOREWORD BY TOMASZ RUT

As my passionate affair with figurative art continues into the second decade, I take great pleasure in presenting this new book of my work. The images selected for this volume illustrate the work I have created since 2001.

My new paintings are not intended to be stylistically innovative, but rather to emphasize the continuity and compliment the coherence of my artistic vision.

This does not mean that I have abandoned all experimentation and pursuit for novelty. Although my method is always consistent, every new painting still presents a fresh technical challenge even if it is only exploring a nuance in color mixed on the palette or a new aesthetic form I dream up and then capture with a model in my studio.

But stylistic evolution and the ingenuity of technical rendition have never been in my focus, except perhaps in the early formative years as I developed my style of painting. No matter how important the form and the mechanics of painting may be as a vehicle in my creative process, the ulti-

mate driving force in the whole journey is the emotion it evokes and the message it generates and conveys. And while always attracted to the beauty of human anatomy, what drives me to paint is the quest to tap into the capability of an individual to overcome doubt and his weaknesses to achieve something greater than himself.

My art has destination and purpose: to comfort the weary, to nourish the hungry, to heal the broken, to guide the lost but also to make the able more able. By staying true to myself and introducing my own aesthetics I hope to benefit my viewer. I hope to assist you. I hope to bring beauty and brightness to your home. With my odes to joy and happiness, but also with my tales of dignity, loyalty, courage and compassion I appeal to your greatness. I want you to be great, even if it is only a small degree greater than you already are. Perhaps the most difficult proposition one faces is to love his fellows despite all reasons he should not. And perhaps, there has been no greater challenge for me as an artist than to continue depicting love for my fellows

despite all invitations to do otherwise.

It is my conscious choice and my insistence to demonstrate the faith I have in humanity through my artwork that may very well define my goal and my entire modus operandi. In writing these words I hope to bring my ideas closer to you. I want my art to reach you.

There is lot of misconception about art. What is art? What is good art? What is bad art? Indeed, these questions will get a stunning array of answers – particularly upon a visit to a modern and contemporary art museum or gallery.

The subject seems to abound with authorities and yet it remains puzzling to the public at large not equipped with degrees in art history or clairvoyant powers to answer a riddle of a tiny black square on a large white canvas. Some people adore Picasso, some hate him, some swear by Pollock and some say all art is dead besides Michelangelo. Some say realistic art is "kitsch" and some are repelled by anything abstract. And most of the others are in apathy on the whole subject.

It appears that the true appreciation of art is becoming more difficult and arbitrary; the "good" art reserved exclusively for the enlightened elite capable of interpreting it. As a result, today's artist himself – more than ever – will question the purpose and viability of his creation. I was personally struck with this early on, in the course and aftermath of my graduate studies at the Art Academies when I witnessed many considerable talents fold up as a reaction to "art for art's sake" (only the mediocre

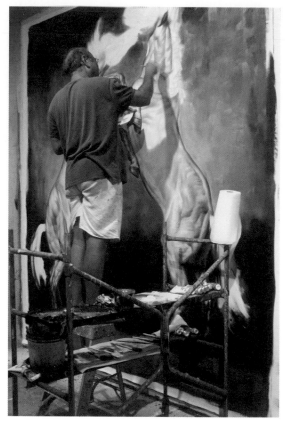

TOMASZ RUT IN HIS STUDIO

seemed to thrive on). Lacking stable data, unable to evaluate good art from bad art other than based on bewildering gamut of tastes and whims of different "experts" and despite showing talent, I myself came close to a conclusion that art is worthless.

Certainly, art doest not have to be either benign or didactic. All art has a reason to exist, even art that repels or is difficult to absorb. I, personally admire many abstract works, full of "angst" for form and color, just as I don't mind whimsical, sentimental art when it shows some valor. But whatever the form art manifests itself in, it is quality of what it communicates that gives it its impact. In fact, I

believe that all art is nothing but quality of communication. Even a blob of black paint on canvas attempts to communicate something in a very sublime way – though perhaps only to the artist who painted it – art for art sake. And by the same token, there seems to be very little dispute about the brilliance and significance of paintings in Sistine Chapel which generate virtually unanimous, overwhelming agreement and admiration. I first felt the power of that communication when I was struck, as if by lightning, on my first trip to Rome. That was when I understood that art is capable of creating a tremendous positive impact on a viewer – in fact changing the viewer's life. This direct experience when I was in my twenties led to my decision to paint.

The very realization that art could be a conduit for communicating my personal ideas and beliefs defined my life's purpose.

Considerable number of figures in my paintings are angels. I believe in angels because I have met them. They have nurtured and inspired me.

And I know that a simple power of choice can make you an angel; you can decide to be an angel. Although I adorn them with wings I don't give them any special features and they are no different, as real and tangible as you and me and the rest of my cast. That way, I hope you can relate to them easier. They just happened to become angels because of their deeds of love or compassion or anything good mankind has to offer.

Similarly, all other figures in my paintings may appear as descendants of classical heroes, draped in classical cloth, but they are meant to be real contemporary people – as my real models are – accessible and familiar.

They are not idealized classical beauties in perfect proportions, just as none of us are perfect either. They are also not portraits but rather generic embodiments of the full range of human emotions. If I give them youthful, beautiful bodies, it's only to accentuate their vitality rather than decay and defeat. If I hint at their mythological ancestry it's to pronounce their god-like, heroic ability. Because we all are – not unlike our immortal, ancient heroes – capable of greatness, perhaps mainly through conquering our downfalls and vice.

Although I purposely glorify humanity and focus on uplifting messages I don't avoid depicting our human weaknesses and faults, to illuminate and accentuate the virtue. I have personally experienced the worst that human kind is able to offer on numerous occasions, and I hardly perceive myself as an eternal optimist. Sin and malevolence, lack of ethical conduct is often impossible to ignore and the designation of right and wrong conduct presents a challenge to many of us in our complex society. I am greatly disturbed by the ignorance, violence, crime, corruption and war we are inundated with on a daily basis and through mass media. Promiscuity, unfaithfulness, betrayal, not keeping one's word, insincerity, deception, disrespect and abuse of all kinds are so prevalent that an amazing number of people would find them

acceptable or mildly objectionable at most. Despair, apathy, grief, pain resentment and frustration are a pitiful, far cry from the emotions one might have felt not so long ago. It fills me with sadness that a growing number of people have to subscribe to caller I.D.s and blocks on their telephones and seem to enjoy spending more time on their computer's Internet rather than interacting in real life – in fact – avoiding each other. And it is quite discouraging that in this day and age of scientific triumph, conquering of cosmos and widely available mental therapy and wonder drugs I don't see much improvement, sanity and happiness on the rise.

Obviously, in my paintings I don't dwell on these subjects. It is also not my intention to instruct my viewers what is right and what is wrong for them, nor do I want to impose any rules of ethical conduct. In fact, I hope some of my paintings clearly express a struggle between ethical values and may imply an ambiguous outcome of which even I am not convinced. In doing so I merely articulate our weakness and without being judgmental I try to offer you my humble assistance to overcome your doubt and to find your own conclusions, your own inner peace and your own comfort level.

Greatness is a luxury. But if you encountered an occasional villain who sabotaged the best ideas you have been nurturing, yet you didn't abandon loving the rest of man, and if you were betrayed by those who you were seeking to support and yet you didn't turn away from the rest of the human race, I am certain that you would feel great. We are all inher-

ently endowed with ability to love, to appreciate beauty, to be self – determined, to communicate, to designate our own goals – and this is a virtue all by itself – but it is through the relentless, uncompromising persistence in maintaining and applying this ability that we can reach a level of greatness. And only here we can truly see the strength, the integrity and the honor. And only here we can see what indeed, made some man immortal heroes.

I could have painted about a million other things, possibly easier to convey but I chose to paint what challenged me most. Beyond the obvious realistic, figurative framework, each and every one of my paintings is to a large degree a testimonial and reflection of my innermost personal considerations, experiences and emotions. It is practically a page in my diary. Ironically, in many instances I am not fully aware what the significances and symbols in my paintings are, nor do I care to know. At first they come about spontaneously, out of moment, a fleeting glimpse. Over the years, as I repeatedly paint certain subject matters, I realize I am trying to express quite definite emotions and experiences, becoming aware of their meanings. When I first started painting my Pietas (an act of consolation between a man and a woman) I did not understand it was my response to the emotional brake up with my ex - loved one. I simply had to put it on canvas in lieu of words I could not find. I don't know if I will ever be able to say that I am totally aware of my entire aesthetic vision, but I can say that my "metaphors" are now clearer to me. The wings

symbolize aspiration – as well as the obvious celestial, benevolent assistance and enlightment. Musical instruments played by youthful figures represent continuous creation of beauty, interest in life, persistence in communicating and accomplishing one's ideals. Struggle between humans or horses exemplify courage and revolt against decay or giving up. The lifting embraces between men and women are meant to show a simple act of human kindness and compassion.

All my paintings have one other item in common – the aging process. My idea was inspired by and crystallized after my discovery of Pompeian frescoes. I was struck by the artistic visions, decayed and crumbled over time by forces of nature, and yet surviving, still stunning and in splendor despite cracks and losses. Not only do they speak to and affect the audiences, but the damage added an additional veil of quality that seems to magnify the impact of what artist was trying to express – the emotions and messages remain intact in spite of all destruction.

The physical universe – not unlike our own considerations and unfriendly actions of others – is constantly exerting a force against beautiful things, things which we value. We perish and die because of the unrelenting advance of time, matter, energy and space, just as we perish and die – to a degree – when we start hating instead of loving. The artificial patina and aura of decay which I create by applying layers of varnish and glazes on top of, hitherto legitimately finished, paintings, is meant

to add dramatic climax to amplify the significance of the content. By this juxtaposition of spiritual versus physical, I hope to convey the quality that transcends time and evokes timeless emotion, but also suggest the eternal nature of our ethical struggle between right and wrong.

What then could help us distinguish good art from bad art? It is my personal observation that the emotional impact of every successful work of art is directly proportional to its technical rendition. In fact, grasping the understanding of the right balance between these two factors has made all the difference for me as an artist. I have wasted a lot of time and canvas seeking technical perfection in my early paintings which did nothing but obscure my purpose and hinder communication. I remember my ex-wife manager literally stealing the paintings I thought were still weak and unfinished from my studio and sending them off to galleries where they became instant hits and best sellers. On the other hand I have also gotten frequently in trouble trying to express overly complicated or perhaps trivial subject matter, in many of which attempts my

technique ceased to cooperate and the paintings never saw the daylight.

There is no such thing as the unanimous standard for artistic perfection (or failure), and whoever evaluates a work of art in terms of brilliance or the lack of it – whether it is an artist or a critic – expresses merely his or her personal taste or penchant.

I believe it is the wrong target for any artist to seek recognition from a critic on the basis of ingenuity of form or subject matter alone, as it tends to throw him out of communication with general audience. And in the extreme it is plain apathetic to pretend to neglect all recognition and the desire to communicate with audience. In any instance, the mission of art is to reach the viewer's emotion and the degree of impact a work of art will have is no more and no less but simply adequate to the technical expertise. And this is how good a work of art will be.

I do not expect the response to my paintings will be always kind and generous but I will continue my best to bring them closer to the viewer. In fact, by going into the limited edition market I want my art to be more easily available, and because of it's a broader reach – accessible to a far greater number of people who I hope may benefit from the introduction.

A painter's life is solitary. I devote most of my time and energy to work in my studio and I consider myself fortunate to be able to maintain a good relationship with my wife, my dog and a few close friends. I often wish I could encompass more

TOMASZ RUT SIGNING

people and activities in my life but perhaps this is yet one more challenge I am facing to fulfill my artistic mission.

Therefore my art shows and letters from my fans are great opportunities to get to know my public and get the input to keep me going strong.

I'd like to end these notes with a few excerpts from particularly moving letters:

"My wife and I have found joy in the work of Tomasz. I am Peace Officer in California and I am introduced to the hostile, ugly side of the world we live in on a daily basis. Collecting Tomasz has brought beauty into my home and my daily life."
Thank you, Eric and Brandi Kendrick

"One [of the paintings] in particular moved me as I have never been moved by art before. The painting is that of a man (which in my own personalization I dubbed a soldier) weeping in the lap of a seated angel. I found myself entranced with the work. It had not been long since my return from my most recent deployment to

Iraq, and I was (am) still learning to deal with the memories and emotions associated with bearing witness to some of the worst crimes against humanity. (Sadaam against his own people) that have ever been committed.

The curse of the soldier is not having your own life in jeopardy, but having to see innocent people brutalized in a way that most people in the free world can not conceive of. Moreover, most of us must deal with these things by ourselves, no matter how horrible they were, because we do not like to "inflict" our burdens on our loved ones, nor do we want them to think of us as burdened. However, the Catch 22 is to avoid permanent psychological damage, one must eventually find an outlet for these very powerful memories and emotions, or be overcome by them.

I had determined never to talk about some of the things I had witnessed. However I am no different from any other man, and eventually I had to find my outlet. This is a very vulnerable time for a soldier that has seen what some of us have seen. The person we choose to confide in must be understanding, but not patronizing; they must relate, but not judge they must be trustworthy enough to hear us, but never tell another; and most importantly they must continue to love us in spit of, or maybe even because of our experiences. Needless to say this is a tall order for any person to fill, and a large responsibility to ask anyone to take. Once that person is found, and that responsibility is accepted, the soldier and their confidant become emotionally and spiritually bound on a level that most people can not relate to. For me that person came in the form of my long time friend and girlfriend. When it came to the point when I had to share these things or be overcome by them, she was there

to hear and comfort me, and help me bear my burden in perfect form. I relate all this to you in hopes that I can fully express the spectrum of emotions that were unleashed when I saw Tomasz's painting. I looked at that painting, and felt like I was the man weeping in the angel's lap, and for me that angel was my girlfriend. I was completely caught off guard, and totally surprised by Tomasz's complete expression of the emotions felt not only by the soldier but the angel as well. As I looked at the painting, captivated by it, I found myself as overcome by emotion as I did the night my girlfriend and I shared that moment.

As moved as I was by the work, I at once sought to purchase it. To my great disappointment, the work was far out of reach of humble budget of a soldier such as myself (it was the original and not a print) my question to you then, is there a print of this work available?

Finally, if you have contact with Mr. Rut, could you please relay the above story to him, along with my gratitude for being able to so perfectly capture what so few people understand."

Sincerely, Captain Kenneth Hessler
82nd Airborne Division
Ft. Bragg, North Carolina

"Thank you for filling my life with beauty."
Sincerely, Shannon Porras

Thank all of you for letting me assist you.
Humbly, Tomasz Rut

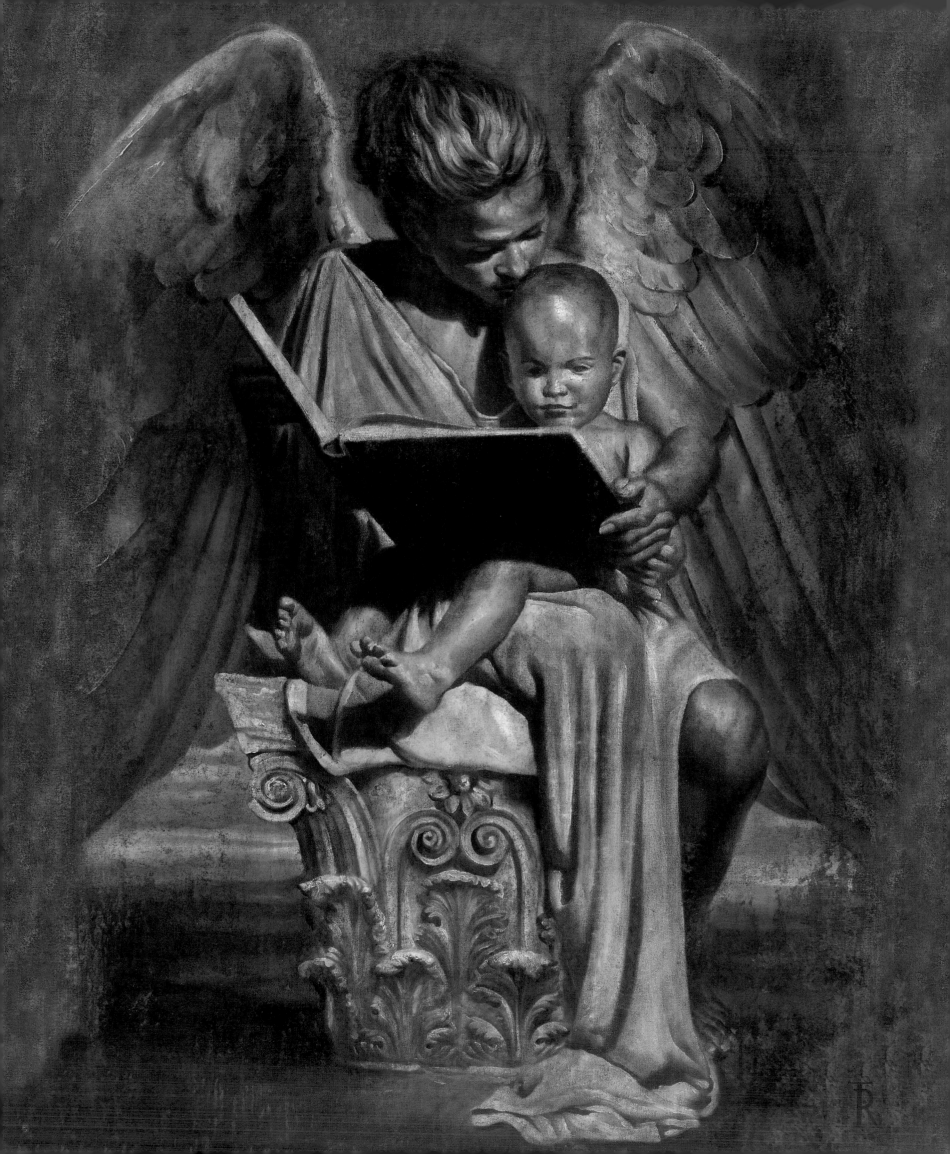

T O M A S Z R U T

When Tomasz asked me to express my thoughts about his work, I was truly honored.

Through collecting some of his incredible masterpieces I felt as though I already knew Tomasz on an intimate level, but after having spent time in his company my deep respect and admiration both for he and his work have only grown.

What I love most about Tomasz's paintings is how they make me feel. It is impossible to stand in front of his canvasses and not experience a gamut of positive emotions. Frequently, I will return from a long business trip, and be stopped in my tracks by my gallery of beautiful Rut paintings. I will stand with my bags in hand, and lose myself in the beauty and timeless passion that is so mesmerizing.

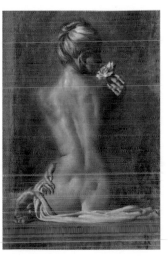

SERENITA, 2005, OIL ON CANVAS, 28 X 45 IN.

Everyone that visits my home, also shares the same feelings. For what makes Tomasz's work unique is that it's so accessible. You don't have to be an art critic or intellectual, to understand his work; you must simply have a soul and be in touch with your spirit, for Tomasz Rut will speak directly to it.

The paintings are simple, without pretense, with classic themes that we can all identify with. His women are beautiful, and ethereal, the kind of women that men dream about being with, and women dream about being.

I have a painting of a beautiful woman in my living room. She is sensual and inviting, but never tawdry. Her eyes are hypnotic, alluring, drawing me in. Her body is curvaceous, and erotic, draped in flimsy cloth, strategically placed to prevent her from showing too much and slipping into sordidness. She is surrounded by a turquoise light that I find instantly calming. I am grateful that this woman existed, if only to grace my walls, so I could lose myself in her timeless gaze. I have no desire to meet her, far better that I admire her from this safe and satisfying distance.

In so many of his paintings, the men have fallen and it is the women hovering gently over them, (either seen or unseen), angelic creatures offering solace from life's torments. Their inner strength and beauty is far more powerful than the more showy superficial strength of the men. I have been

there, as have so many other people, and was rescued by just such an angel. When I look at the painting next to my piano, I see myself as a little boy and the beautiful woman draping me in the red robes as my protecting angel, she is whispering in my ear, "Get up Roland, it will be Ok, you can make it, fight on, you'll be fine." I cry like a boy, and then I get up.

In my dining room are a man and a woman, bathed in vibrant orange light. They are holding on to each other, their love illuminates the canvas, and protects them from the evil that is in the world. I have been fortunate to spend time with Tomasz, and know that he only wants to paint beautiful images, that elevate his viewer's consciousnesses. I agree with him, there is enough filth and crap in the world, why bring it into his art. It is only the presence of extreme evil that gives us the juxtaposition of divine goodness, creating this continual conflict. Sometimes I can see my couple holding on very tight, I feel as though they are holding on for grim life, positive that only their pure love will conquer all adversaries.

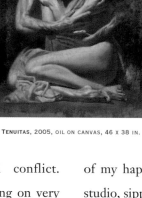

TENUITAS, 2005, OIL ON CANVAS, 46 X 38 IN.

Then we have his horses, ah his incredible awe inspiring stallions, painted on huge heroic canvasses. Fiery white thorough breeds, kicking up dust, and rebelling against each other or their purported captors. For me they represent the epic struggle

within ourselves against our inner demons. In my painting, a lithe man does battle, his sinewy muscles rippling as he vainly attempts to control the untamable beast. Rut has interestingly left out the reigns, as if to confirm that the heroic battle is in our heads, it is against ourselves and in many cases un-winnable. The demons will always be there it is up to us to control them.

In all of his paintings the heroes and heroines are stunning, mortal examples of physical perfection. Somehow Rut goes deeper and finds their inner beauty, the self that lights up the canvas with searing truth. He surrounds his figures with vibrant colors. Colors that soothe, calm or excite depending upon the mood of the piece. Then lastly, he ages the canvas with his unique process, so that you feel that the masterpiece is centuries old.

I have been privileged to spend time with Rut at his home. Some of my happiest moments have been spent in his studio, sipping green tea, classical music blaring as I watch the master at work. The first thing that strikes you when you enter his safe haven is the aroma, the sweet smell of oil paint on canvas, a pungent reminder of the ageless, heritage of Tomasz's craft. On the walls are usually four or five canvasses at different stages of completion. Some in their infancy, bold pencil line drawings waiting to receive their flesh, others in their adolescence,

fully formed yet waiting for the final flourishes, and seal of approval from Tomasz's paternal brush.

It is engrossing to watch him work. His brush becomes an extension of his arm, as he dabs confidently at the colorful mound of paint, extracting exactly what he is looking for. You can see that he totally loses himself in his work, all of his prodigal talent, training, passion, and vision combine; he is at one with the canvas, and magically beautiful images appear. Watching him create, I have always felt both honored and slightly voyeuristic, as though I am peeking through the portals of time. Look at the canvasses, drink in the aroma, listen to the music, watch his hands mix the paint and then move deftly over the canvasses and you could just as easily be watching any of the past masters, Michelangelo, Da Vinci, Rubens, the list goes on. There is no doubt in my mind that I am watching greatness, an artist that will be revered for generations to come, and I am grateful to be an observer if only for a moment.

This total creativity pervades everything he does. After an afternoon of painting we will often retire into his kitchen. Those same hands will conjure up a meal, more exotic and exciting than any restaurant. Always accompanied with robust Chianti's, Tomasz will serve mouthwatering appetizers that could hail from Asia, India, or Italy, followed by sumptuous meats, cooked to perfection.

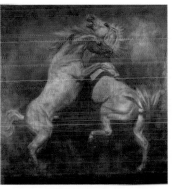

ADMISSARI, 2001, OIL ON CANVAS, 96 x 112 IN.

He will only use the finest, freshest ingredients and like everything in his life, he does it exceedingly well, and always with immense passion.

His home, situated on a substantial slice of waterfront property is another monument to his artistic vision. When he invested in the home, it truly bared more resemblance to the Brady's house than a bohemian's. With vision and incredible persistence, Tomasz and his beautiful Estonian wife Anu, have transformed their home into a breathtaking Bali style estate. Walls were taken down to add light and cheeriness, windows added to capitalize on either waterfront or lush tropical views from every angle, rich mahogany floors and doors have been added to give warmth, and a chefs kitchen has become the centerpiece for Tomasz to create his culinary masterpieces, and relax with friends.

After painting and cooking, Ruts next great passion is gardening. Like his other interests, his forms must not only be breathtaking but also exotic, to satisfy his refined tastes. Luxuriate in his pool and you will be surrounded by colorful Frangipanis, African Royal Poinciana's, Jamaican red ginger, Chinese Bamboo and Amazonian Orange Haleconia's that adorn his hand made bamboo fence. A forest of Coconut palms provides some shade and sway in the tropical breezes that come from the water. He even has a pomegranate tree that bears delicious blood red

fruit. In order to enjoy this tropical paradise, Tomasz built with his own hands a brick outdoor kitchen with plant covered trellis, and a beautiful wood gazebo, with Tahitian thatched roof. To relax with Tomasz and friends on a cool Florida evening, sipping red wine, enjoying a gourmet meal, while the wind gently ripples through the white gauze of the pagoda, the fragrance of the night blooming jasmine filling the air is truly heavenly.

Be warned, if you do spend time with Tomasz he doesn't suffer fools gladly. Don't try and impress him with pseudo intellectual physco-babble, for he will lacerate you with his biting intellect. Like his art, he respects honesty and passion. He likes to surround himself with regular people from all walks of life; no matter whether you are an electrician, a plumber, or a chef, just be great at what you do, and be yourself. We are all seeking significance in life, and art is a remote medium wherein artists are frequently separated

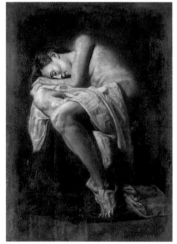

OVIDIA, 2003, OIL ON CANVAS, 26 X 38 IN.

from their adoring audience. If you are fortunate enough to spend time with Tomasz, share your sincere appreciation for his work, how it makes you feel, and how it may have changed your life, as it has mine, and it will greatly endear you.

As I savor the collection of Rut paintings that grace my walls, I often ponder at what precise mixture of experiences helped mold Tomasz Rut

into the great artist he is today, and form his paintings into the excruciatingly emotional pieces they are. What captivates me in his work is the intensity of real feeling; where there is elevated beauty I can't help also feeling pathos and pain. His men have fallen and seek spiritual resurrection from their beautiful protecting angels, his women are hauntingly attractive but often seem trapped in a remote sadness, his men are fighting horses and conquering inner demons. What could have happened to Tomasz to have caused this thirst for beauty, contrasted by pain and the belief in the eternal struggle of the spirit to conquer all?

Could it be his childhood growing up with a famous Olympic athlete father, a beautiful specimen of a man who apparently held a brutish disregard for his son's creativity.

Or his mother a holocaust survivor and artist, who left her son at age thirteen to virtually fend for himself while she flitted off to America, never fully, giving her son the maternal care and recognition most children need and deserve. Fundamentality, I feel that like most of us, Tomasz is a little boy, who needs a lot of love. The love that he both gives and receives from the perfect muses that grace his canvases, and is so palpable in all his paintings. Or maybe it was growing up in Cold War Poland, with communism the great suppressor of men's individuality and spirit. The crumbling decay of

communism could easily be seen as a simple metaphor for the cracked canvasses and decay expressed around the edge of Ruts paintings. Yet Rut's indomitable spirit shines through his hero and heroines a guiding light that rescues them from all adversity. But I know that Tomasz would chastise me for way too much thinking, and encourage me to simply feel.

In any event there is no doubt that Tomasz Ruts gifts are God given. I would love to have been an observer when a ribald young Rut famously showed up late for his final exams at the Royal Academy of Warsaw, still intoxicated from a night of carousing with his friends. Kudos to the academy for instantly recognizing his prodigal talent. I imagine young Rut as a rock star artist, his carefree demeanor belying his blazing talent. However it is his single minded vision, and persistence that drives him to excel, and keep creating in such a prolific manner.

This magical mix of inherent gifts and self drive have combined to give us a truly great artist. One that I am grateful to know both personally and through his art. Thank you Tomasz, for the beauty you have bought to this world, for the masterpieces that you have created and for selflessly sharing the gift of your genius with us all.

Now please excuse me, I have some paintings that need my attention.

By Roland Nairnsey

PLATES

Ex Animo, 2001, oil on canvas, 39 x 48 in.

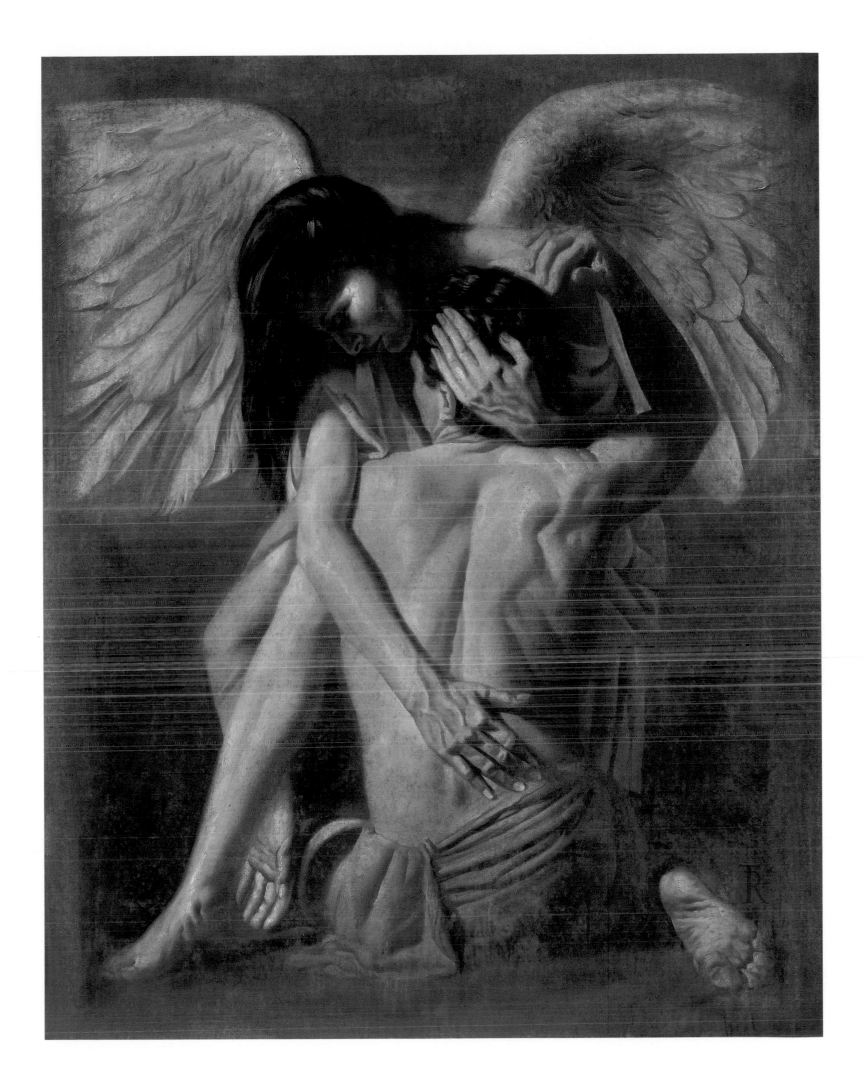

FRAGILITA, 2001, OIL ON CANVAS, 34 X 48 IN.

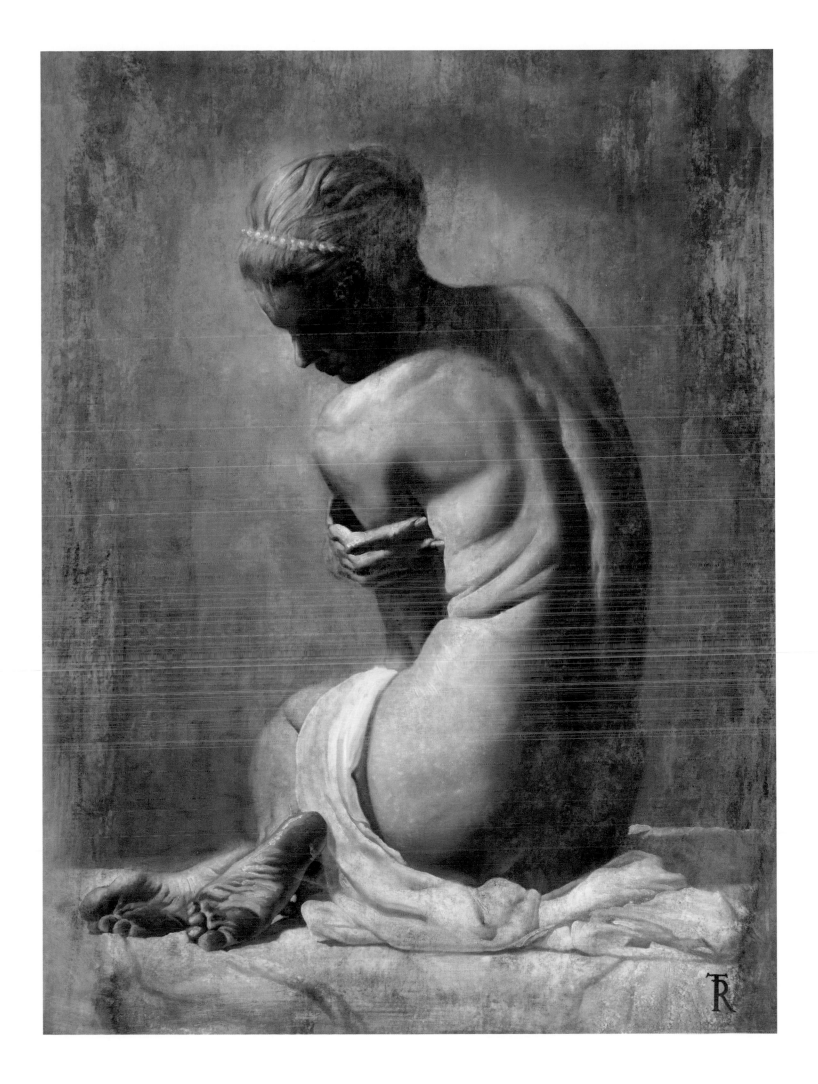

GRATIA, 2001, OIL ON CANVAS, 28 X 46 IN.

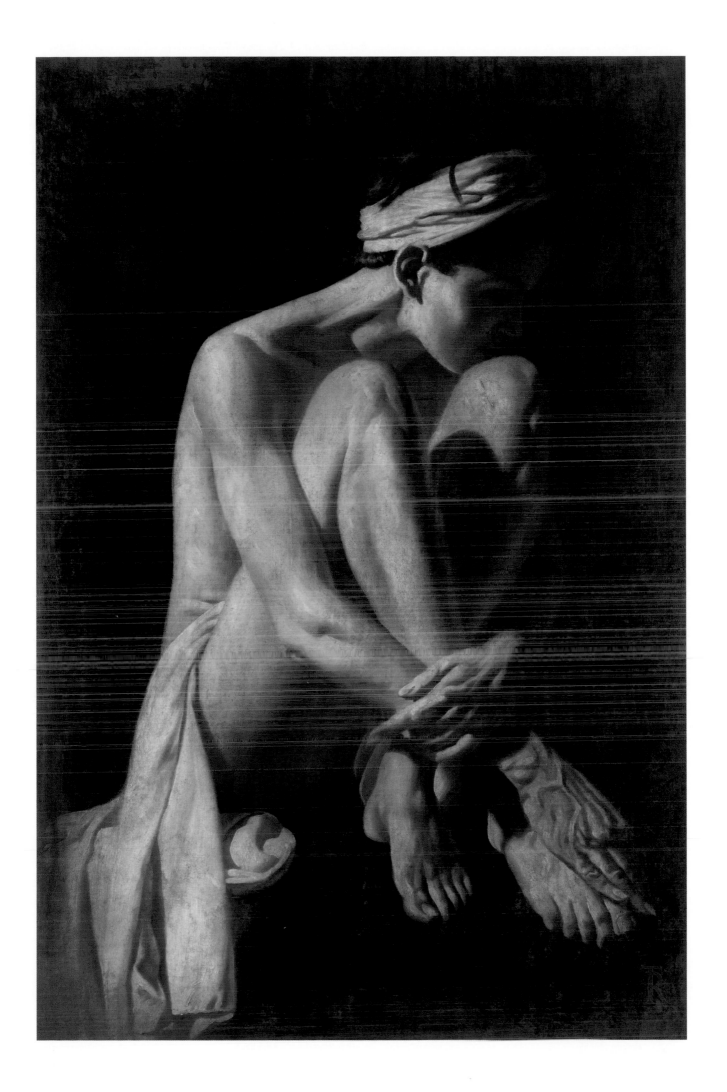

Il Prendo, 2001, OIL ON CANVAS, 46 x 66 IN.

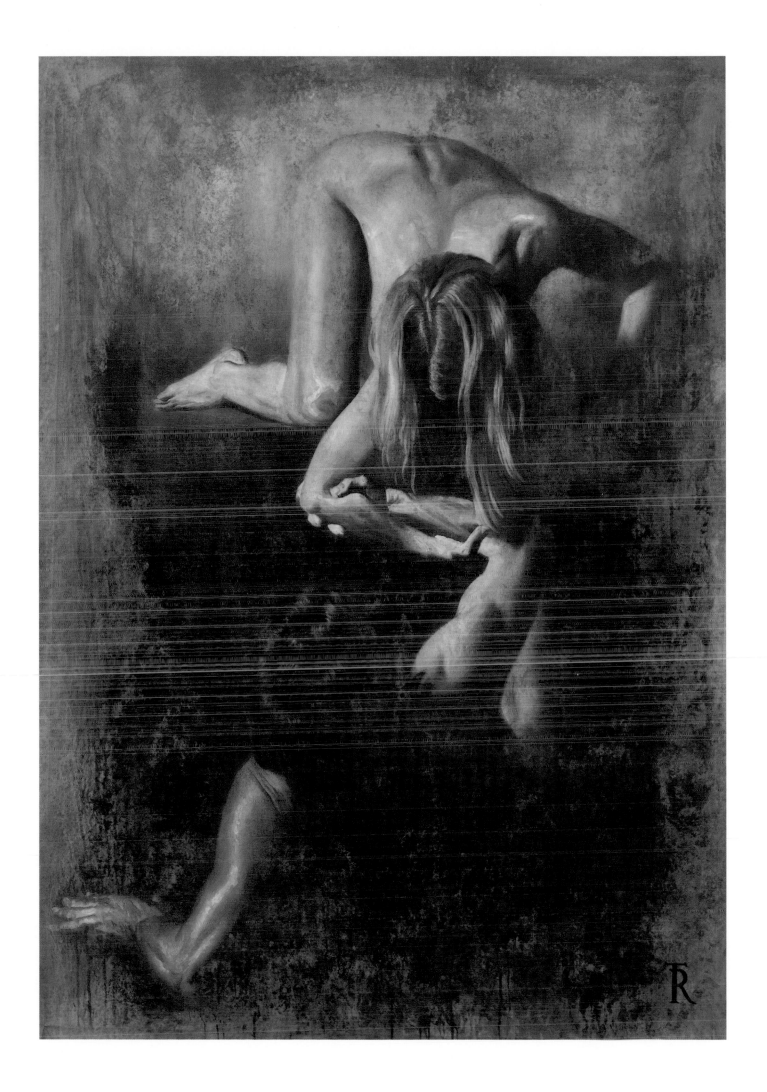

NASCONDARE, 2001, OIL ON CANVAS, 46 X 46 IN.

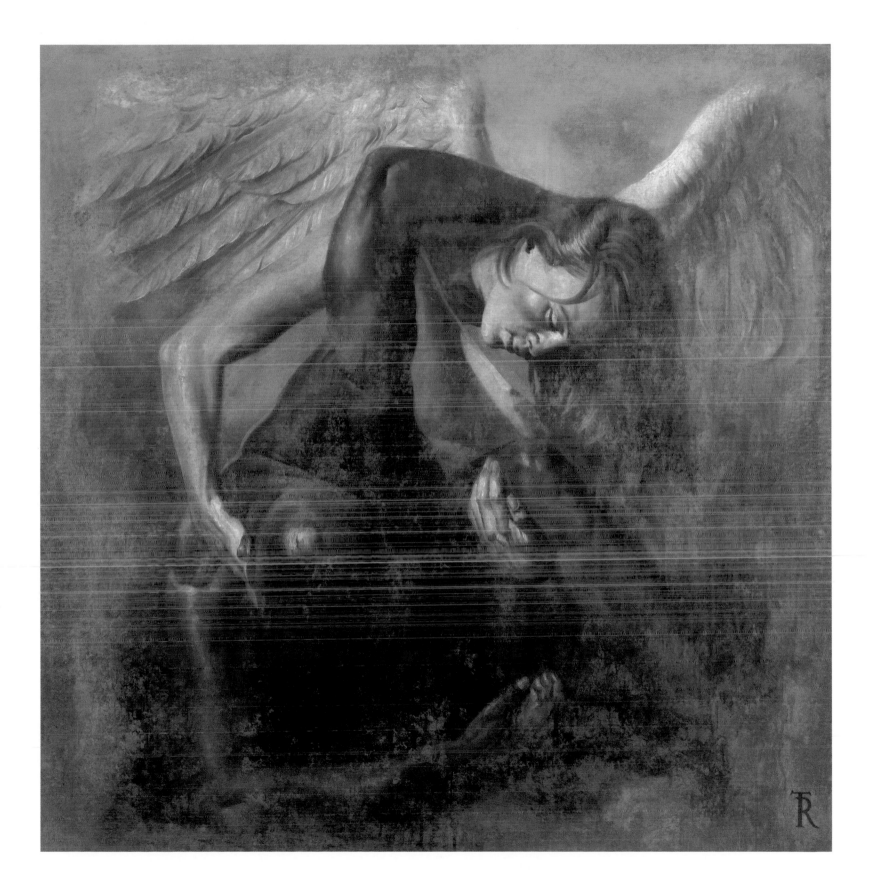

PRESENTARE, 2001, OIL ON CANVAS, 35 X 46 IN.

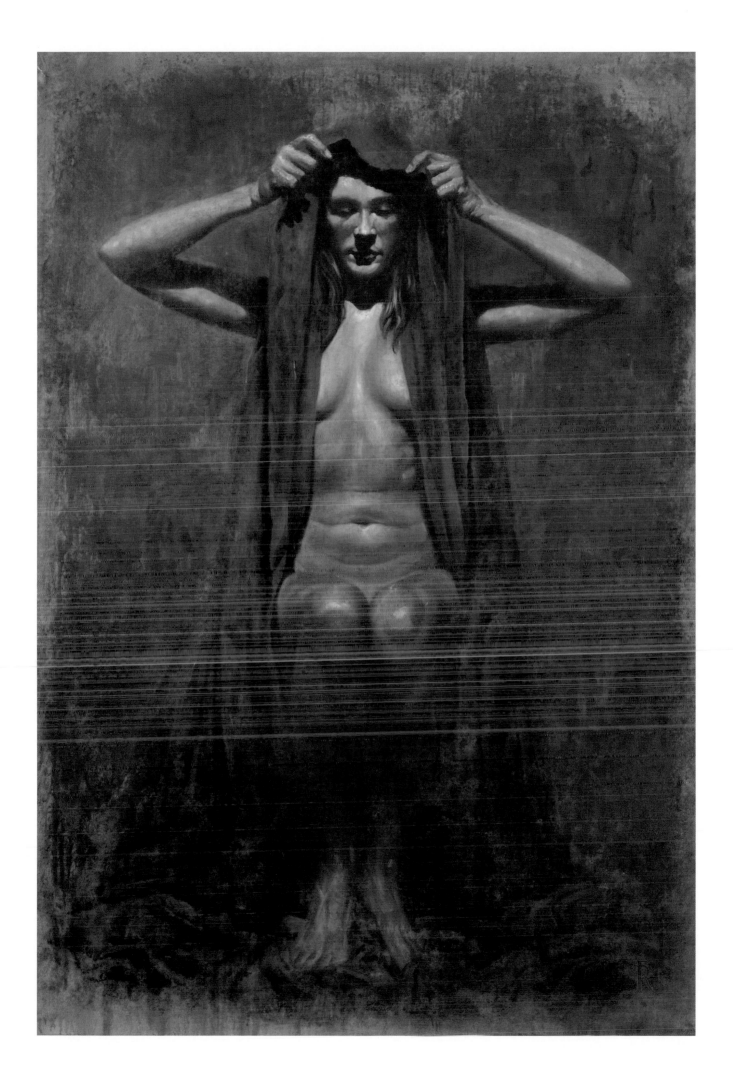

PRO FORMA, 2001, OIL ON CANVAS, 47 X 39 IN.

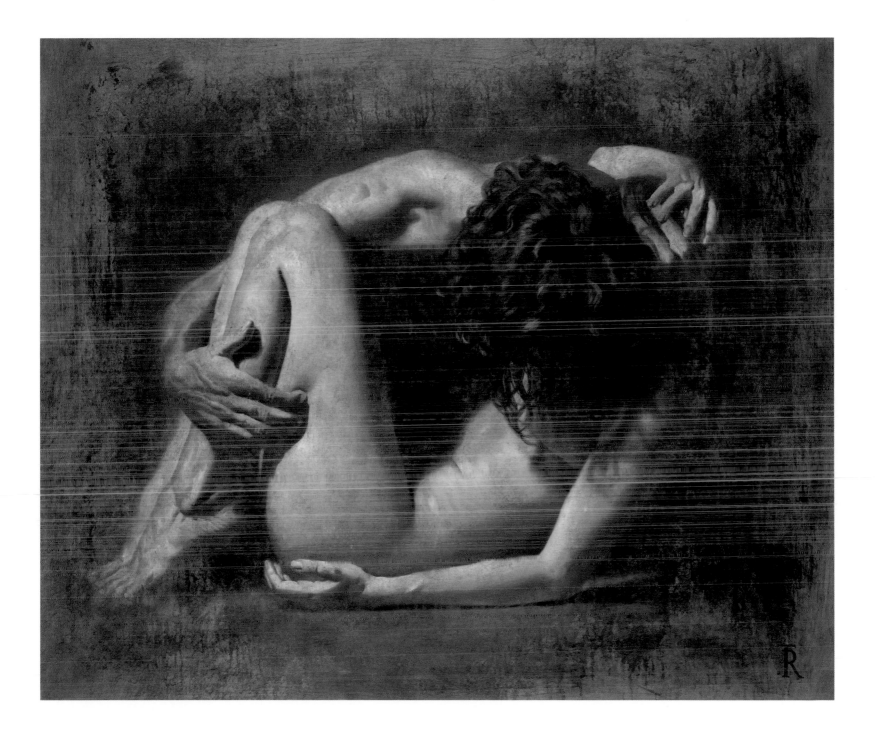

SINCERO, 2001, OIL ON CANVAS, 38 X 48 IN.

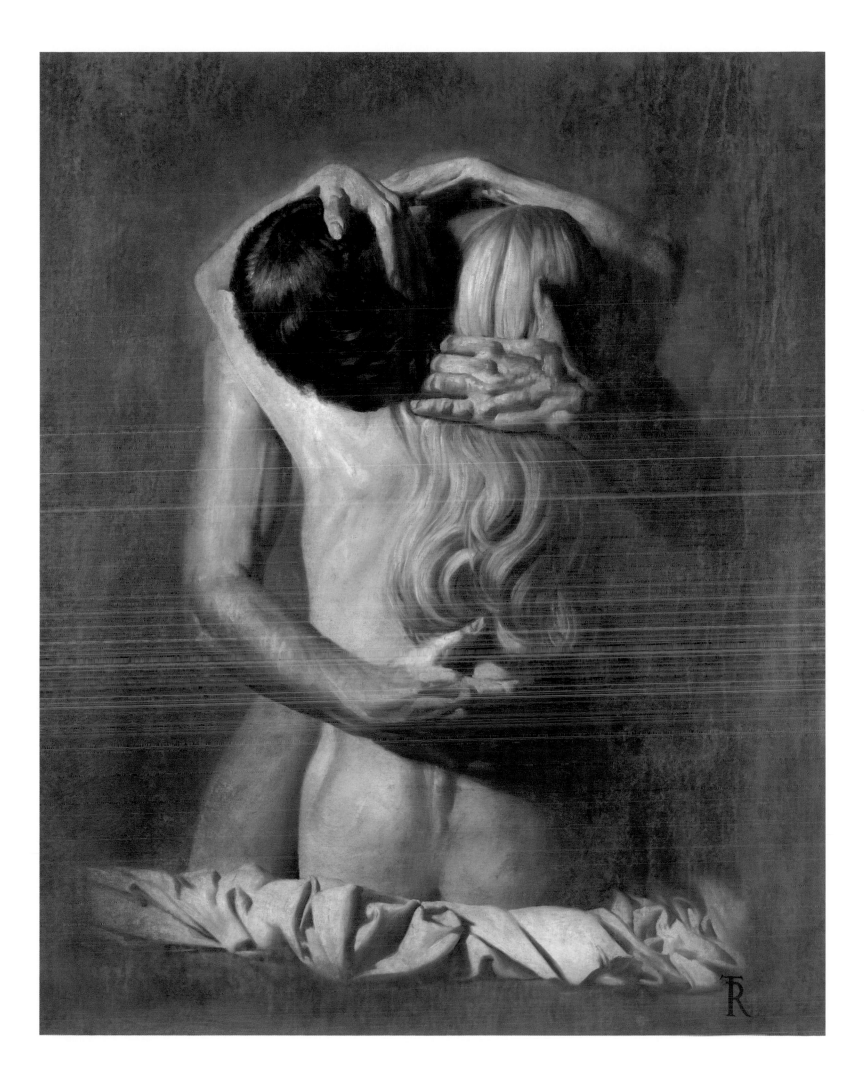

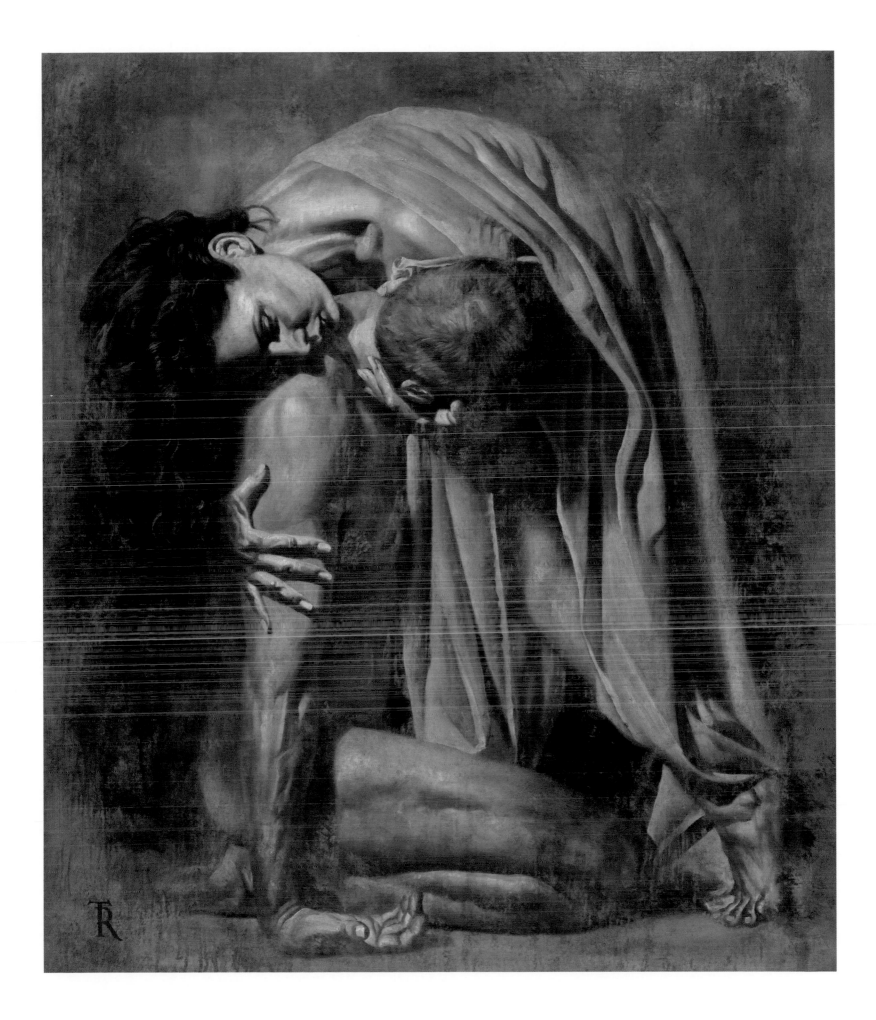

AD UNUM, 2002, OIL ON CANVAS, 42 X 46 IN.

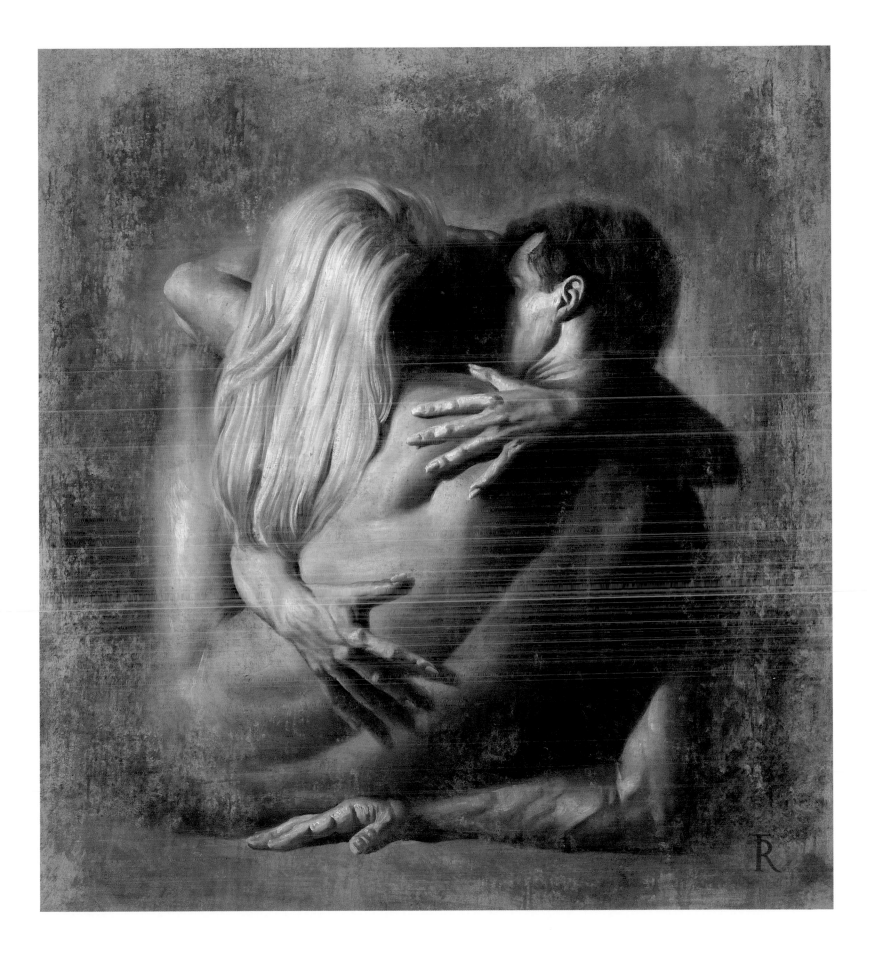

AMBIENTE, 2002, OIL ON CANVAS, 62 X 46 IN.

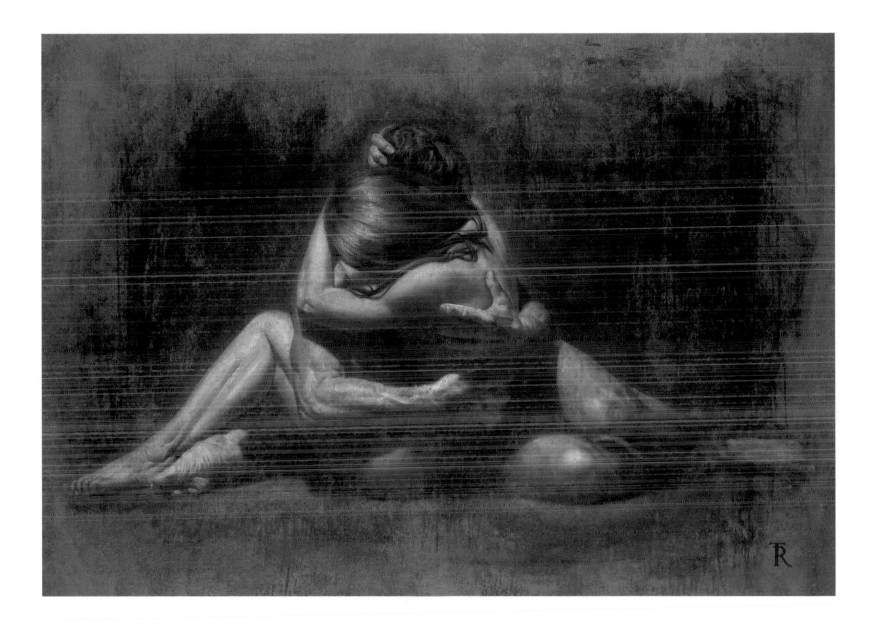

ARTE FICIO, 2002, OIL ON CANVAS, 68 X 44 IN.

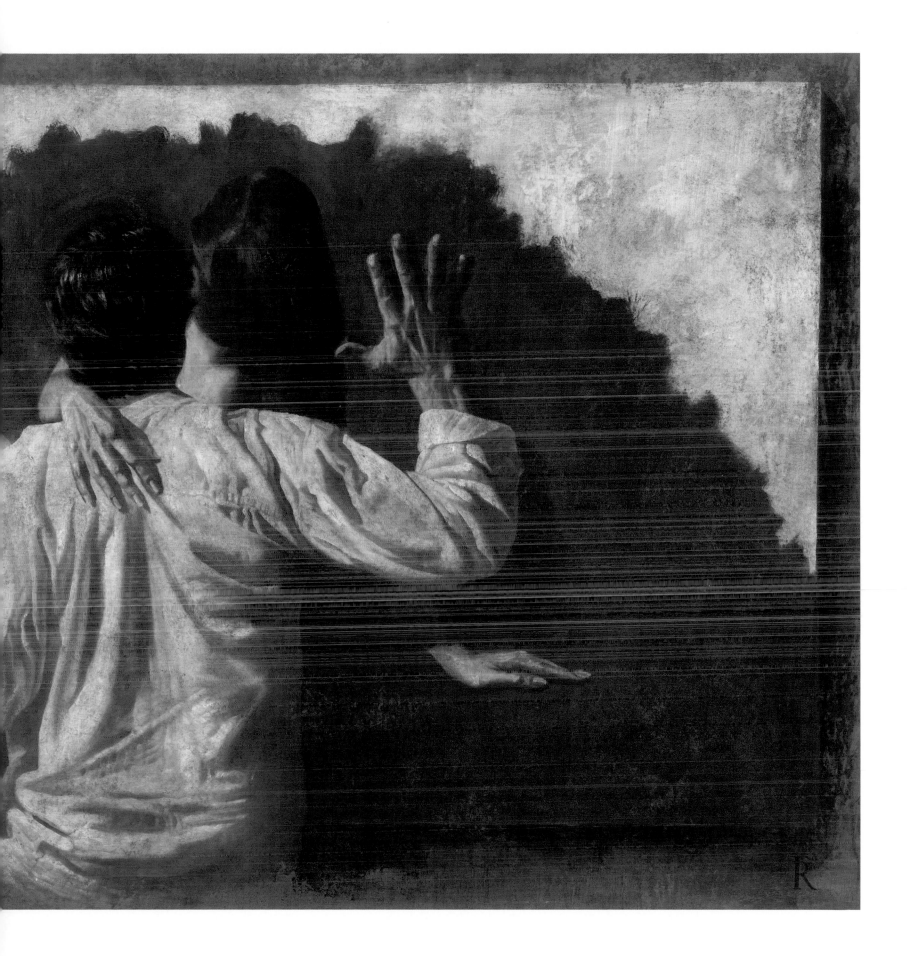

Ex Tempore, 2002, oil on canvas, 46 x 58 in.

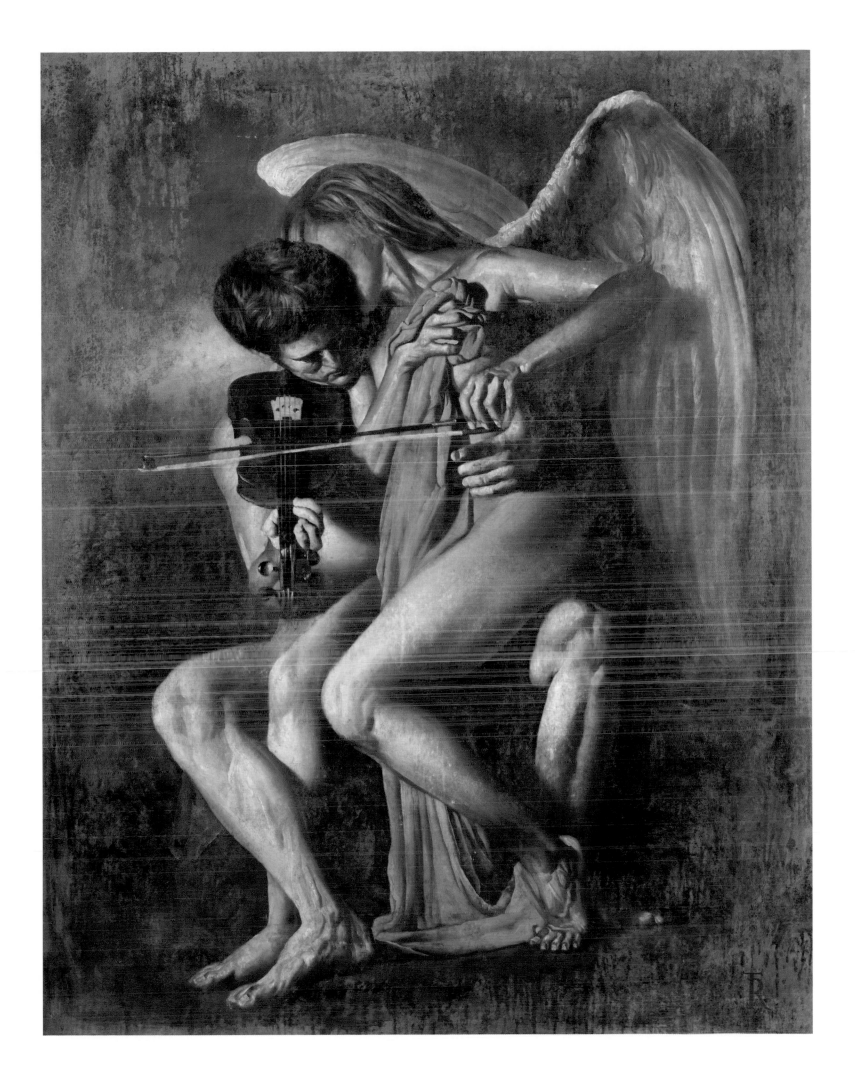

EX TUTO, 2002, OIL ON CANVAS, 46 X 42 IN.

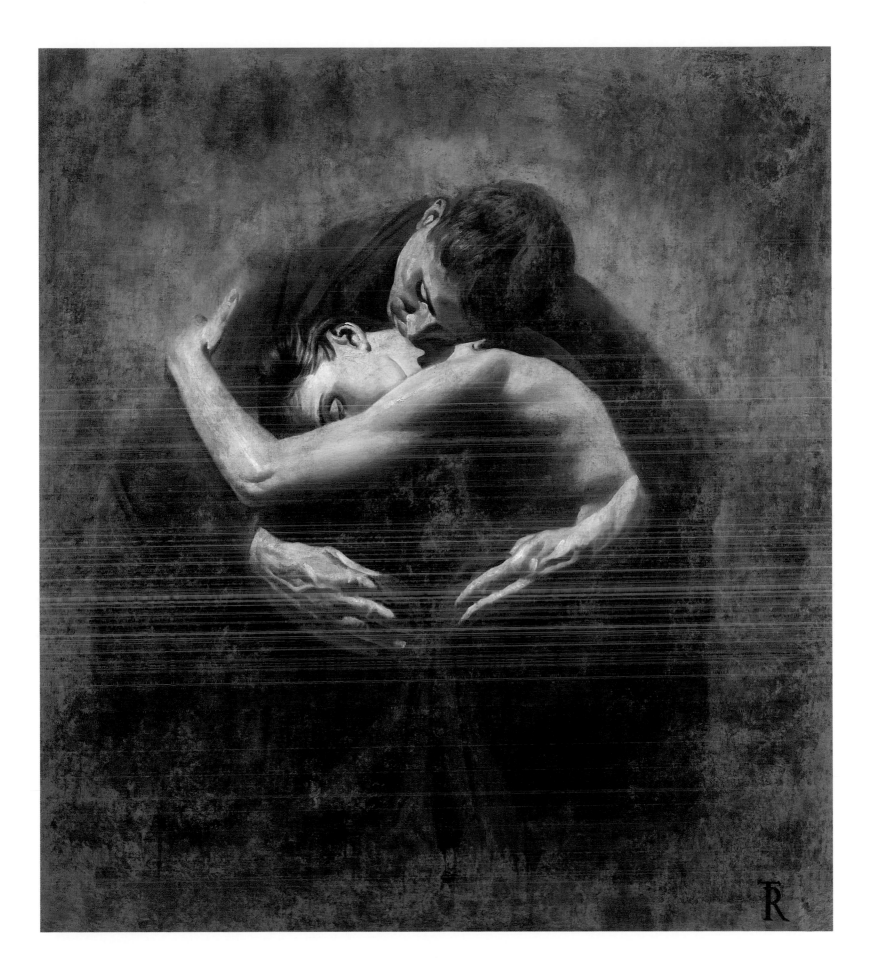

FIERO, 2002, OIL ON CANVAS, 76 X 104 IN.

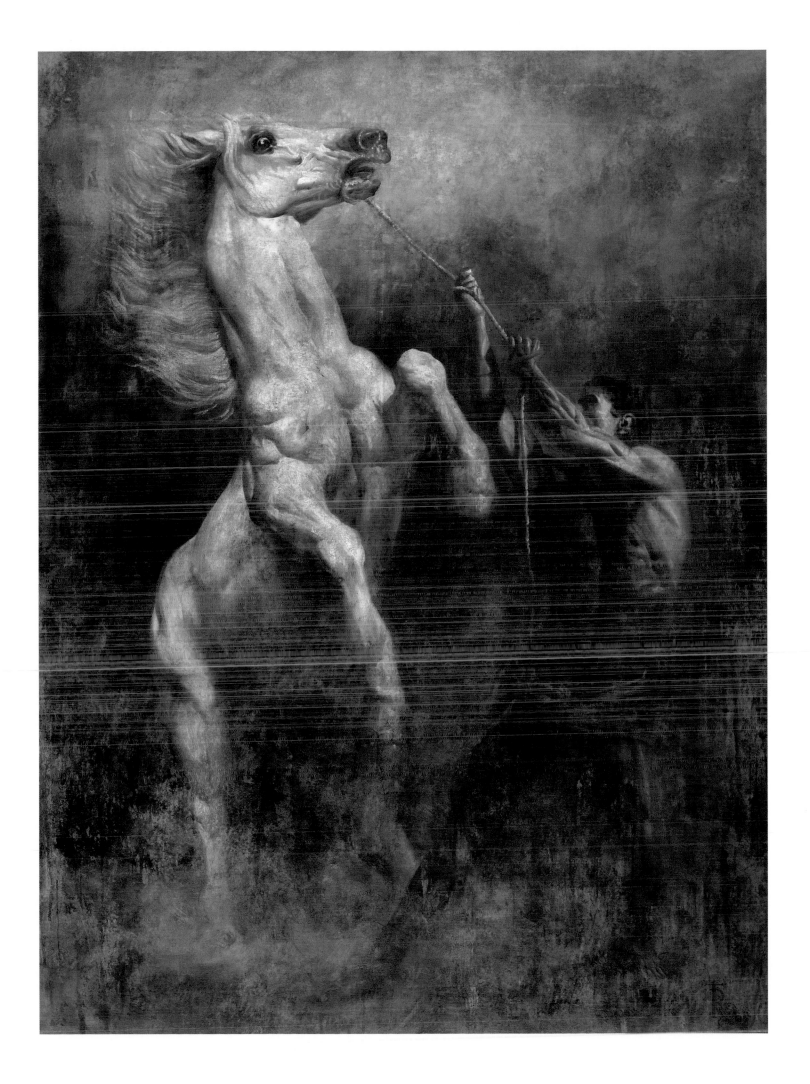

ILLUMINATA, 2002, OIL ON CANVAS, 42 X 50 IN.

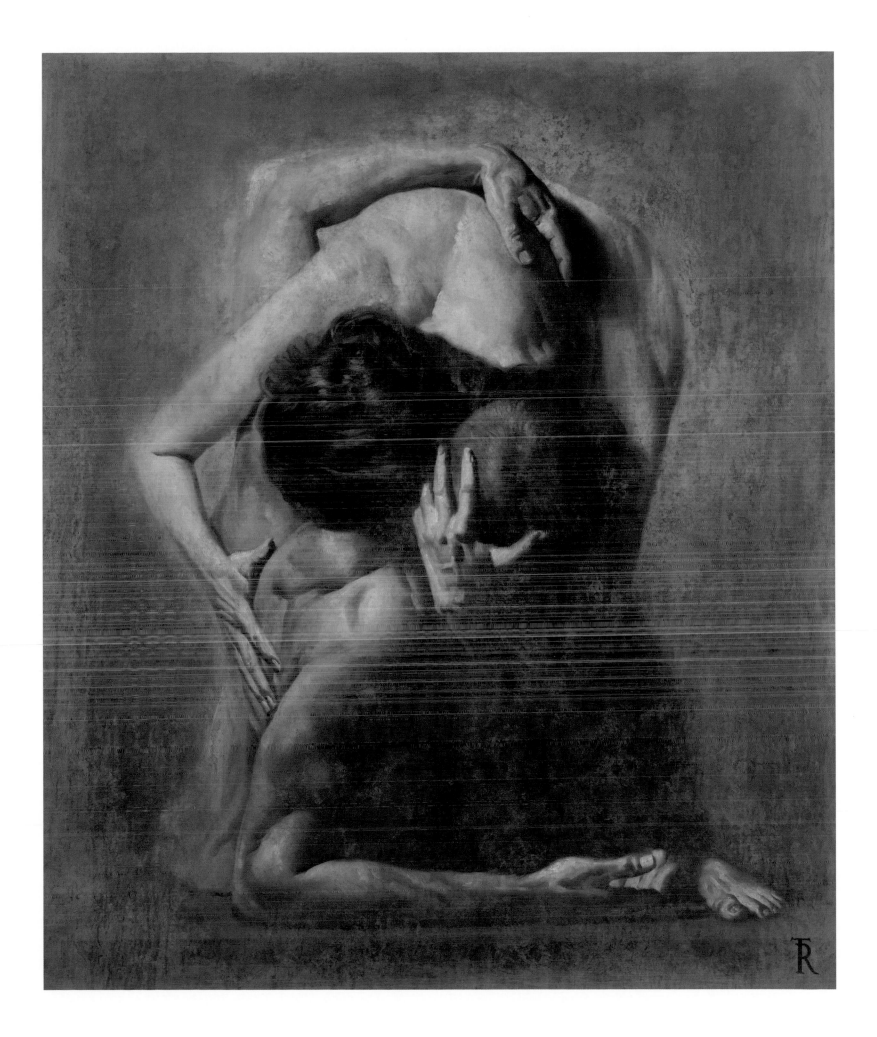

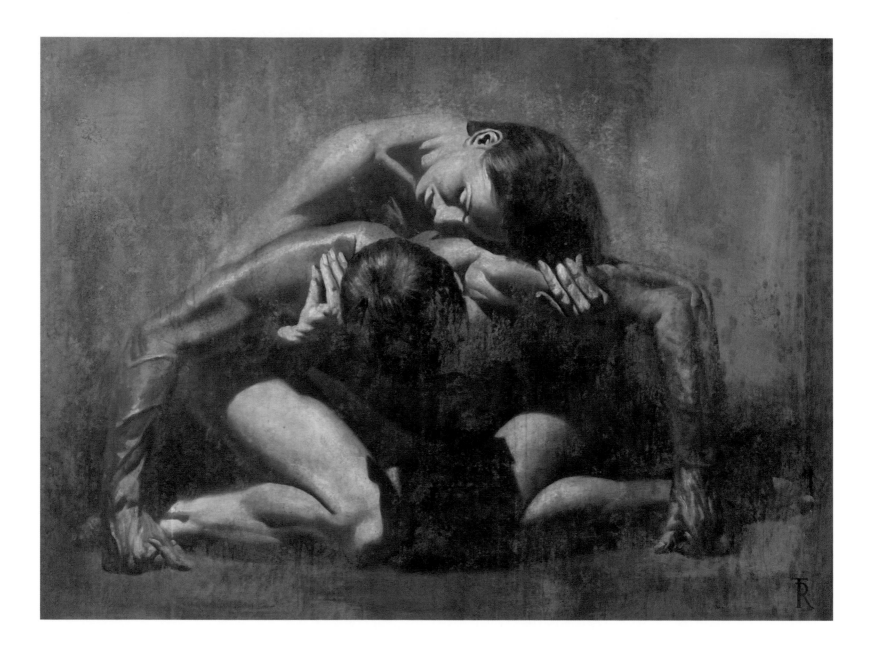

INSCENDO, 2002, OIL ON CANVAS, 54 X 42 IN.

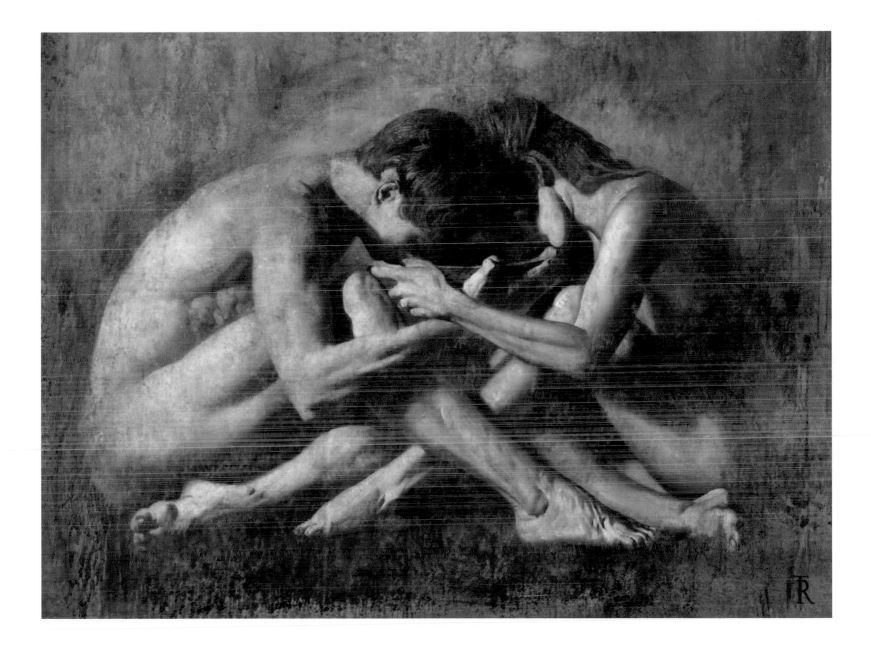

Inter Se, 2002, oil on canvas, 56 x 46 in.

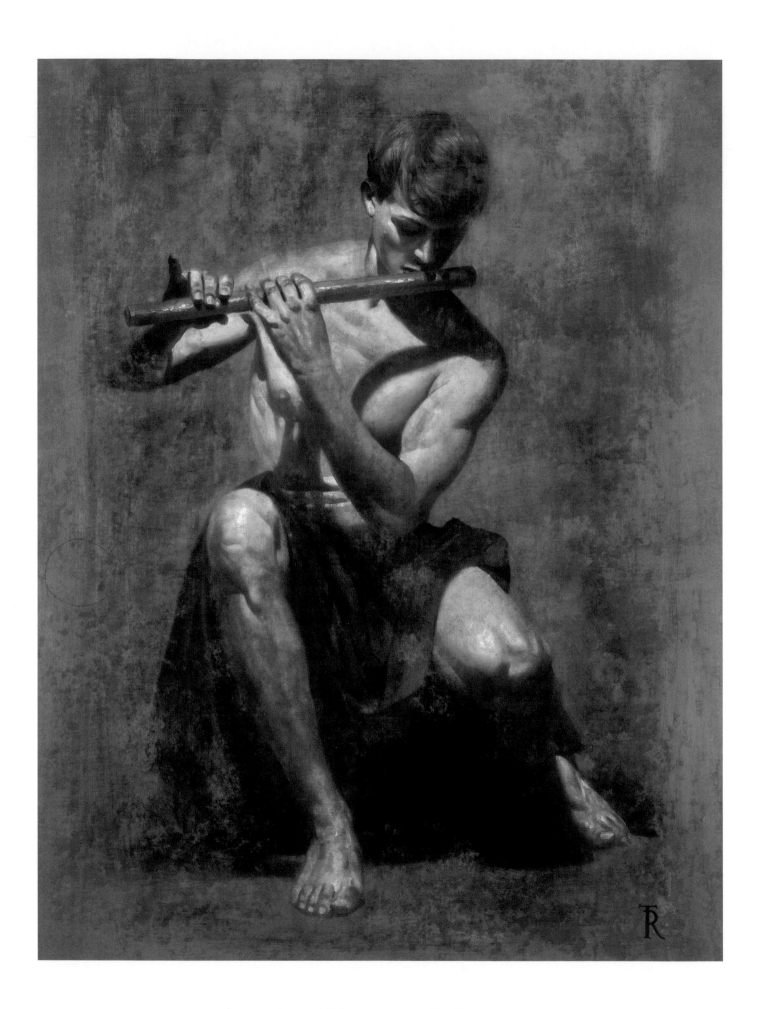

STANZA, 2002, OIL ON CANVAS, 32 X 46 IN.

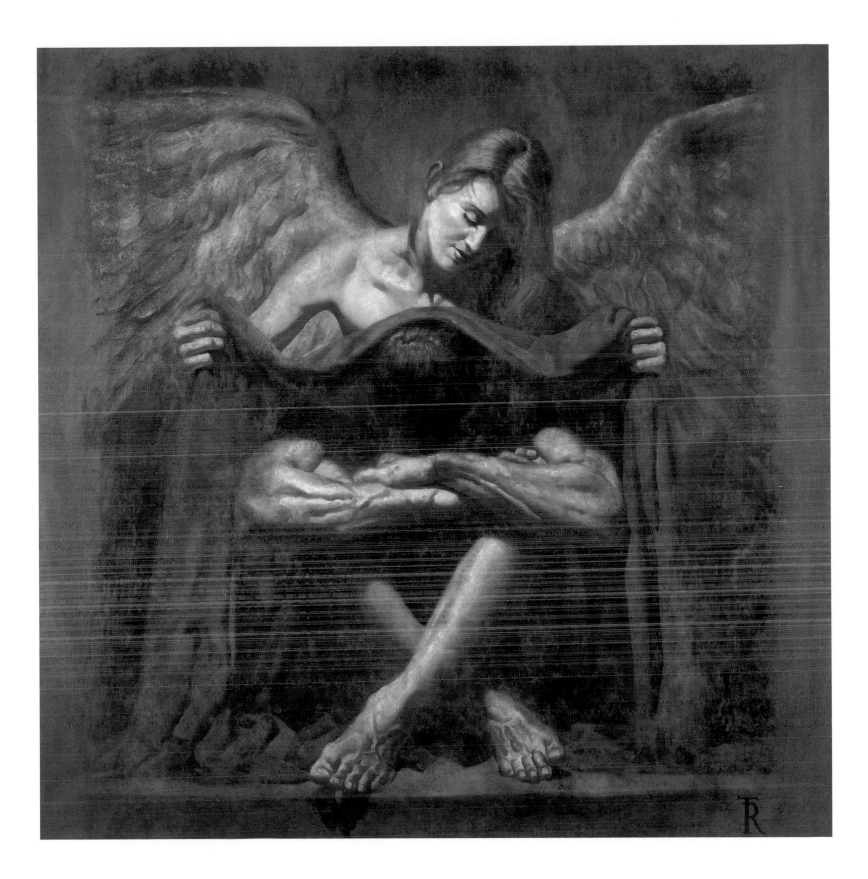

EVOCATA, 2002, OIL ON CANVAS, 42 X 46 IN.

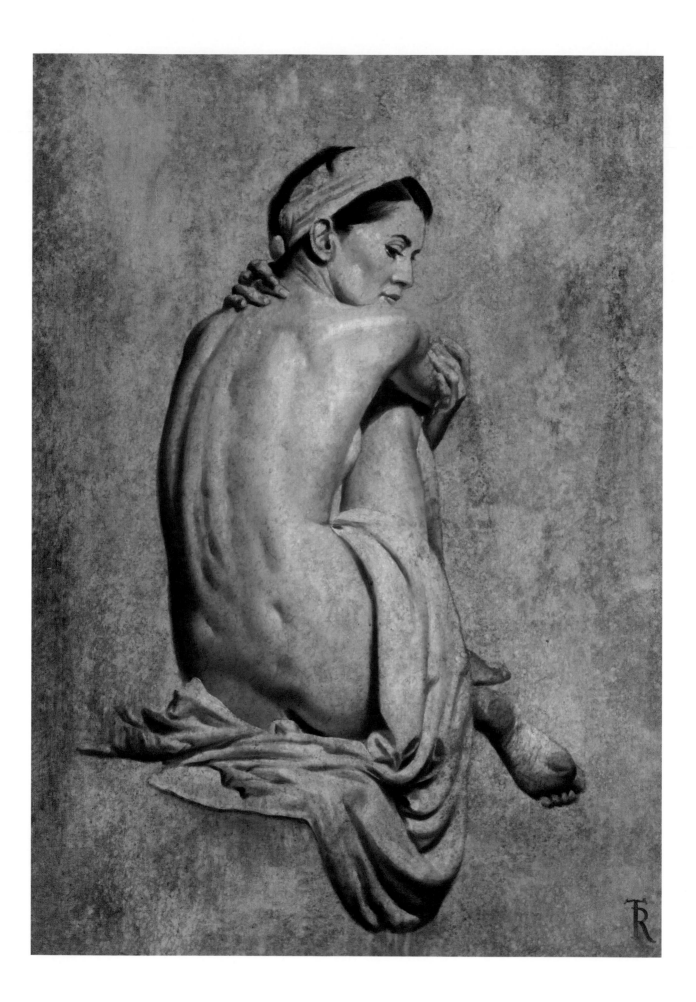

NOVELIA STUDY, 2002, OIL ON CANVAS, 22 X 32 IN.

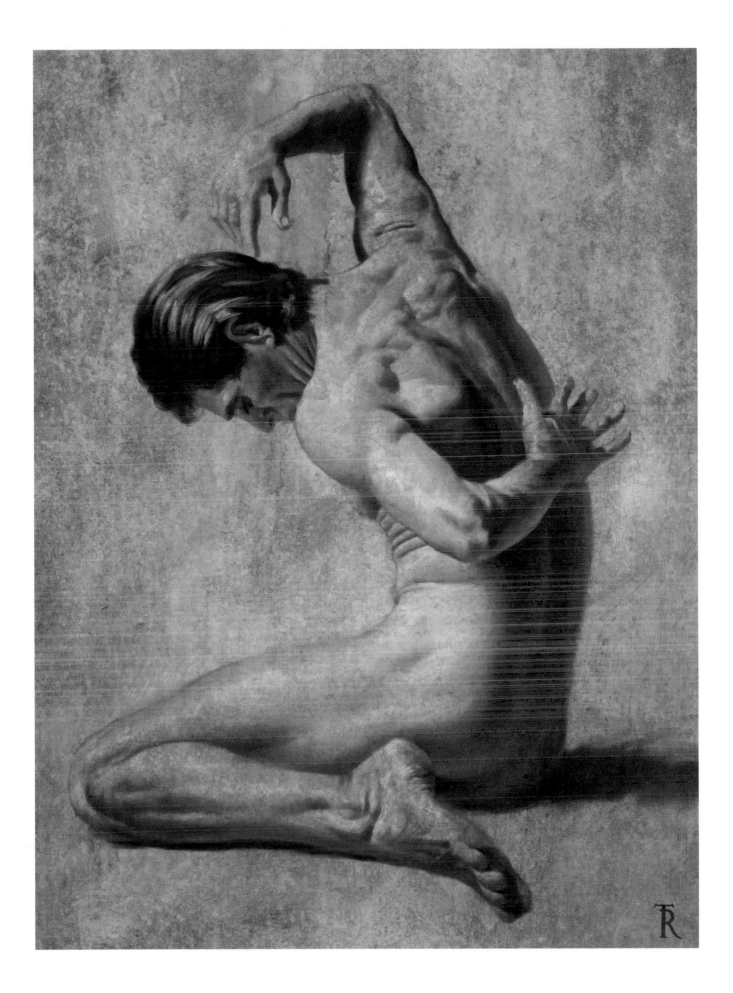

Fausto Study, 2002, oil on canvas, 22 x 32 in.

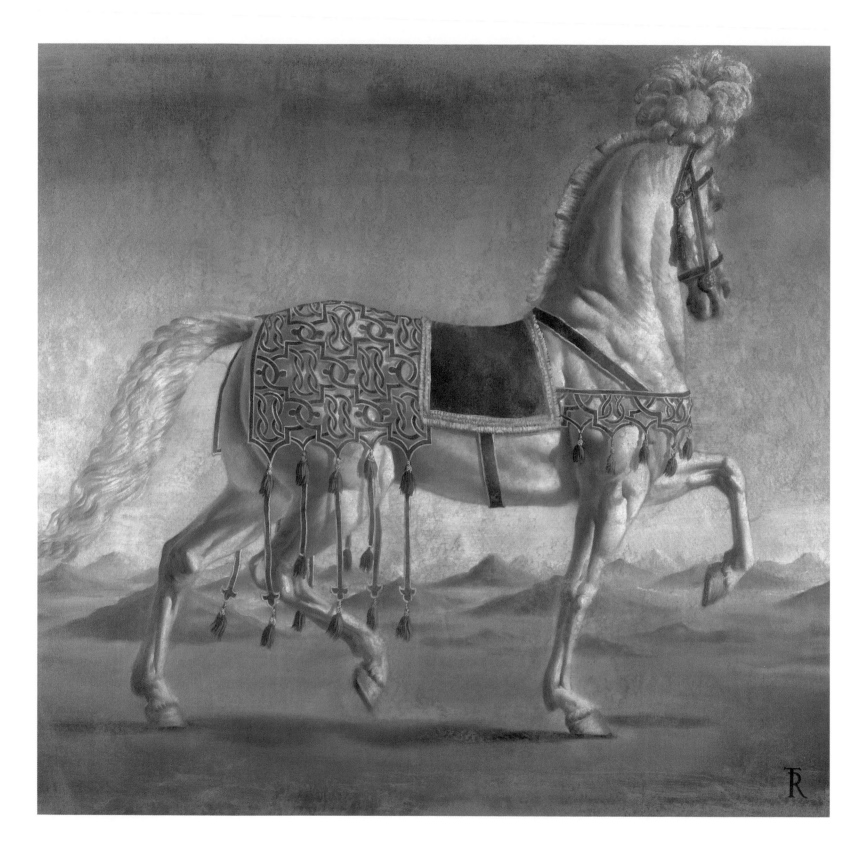

Quo Vadis I, 2002, oil on canvas, 67 x 64 in.

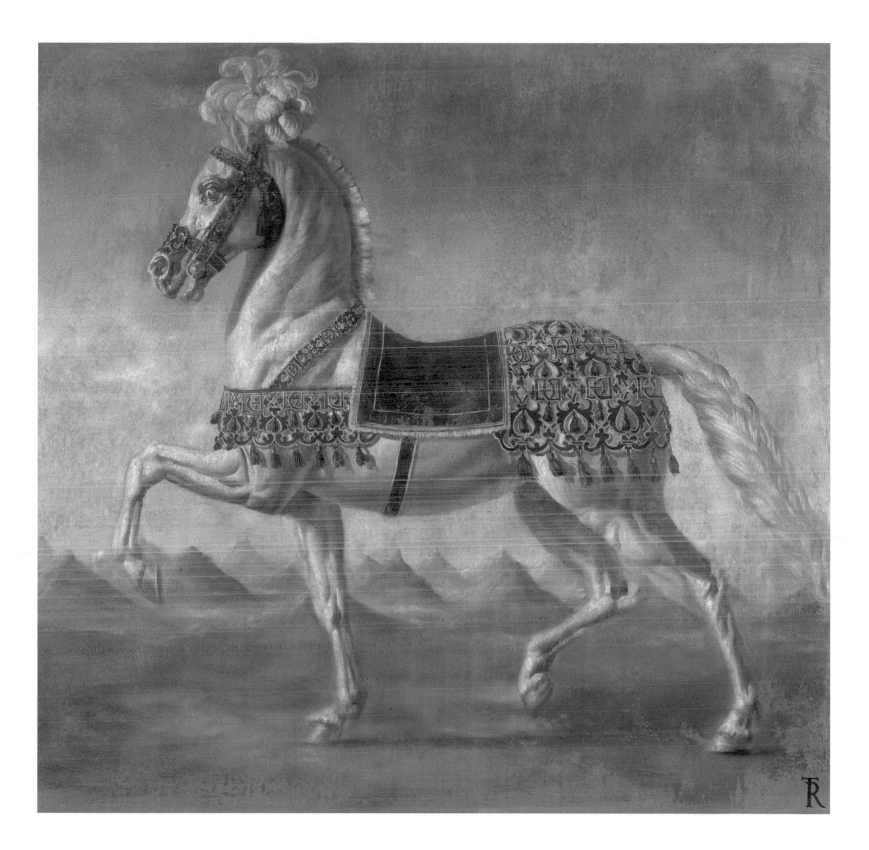

QUO VADIS II, 2002, OIL ON CANVAS, 67 X 64 IN.

NOLI TANGERE, 2002, OIL ON CANVAS, 58 X 44 IN.

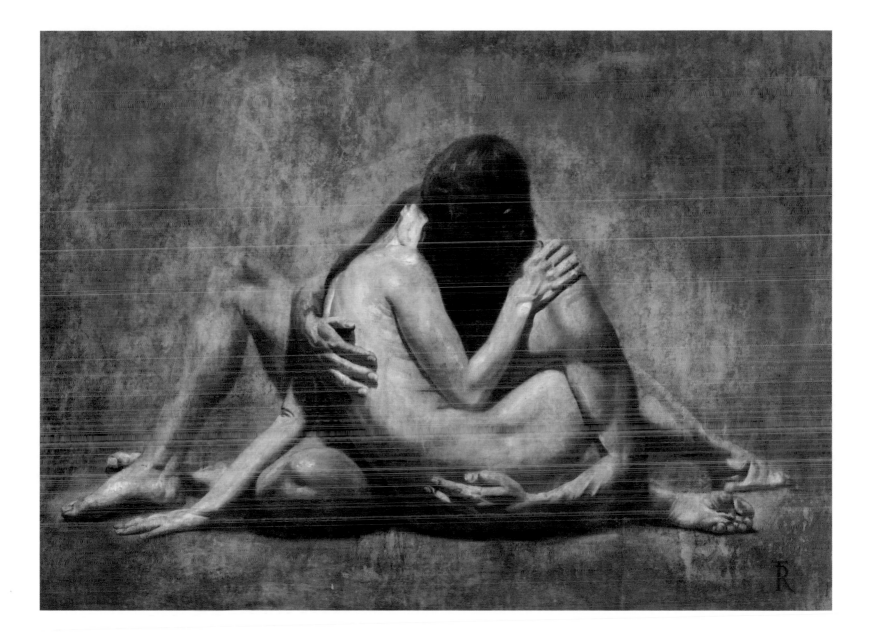

SERENITAS, 2002, OIL ON CANVAS, 74 X 44 IN.

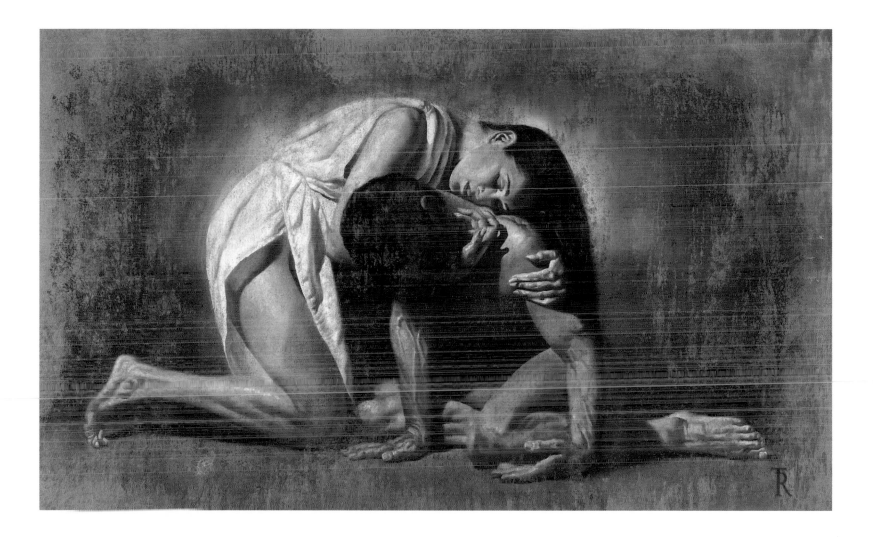

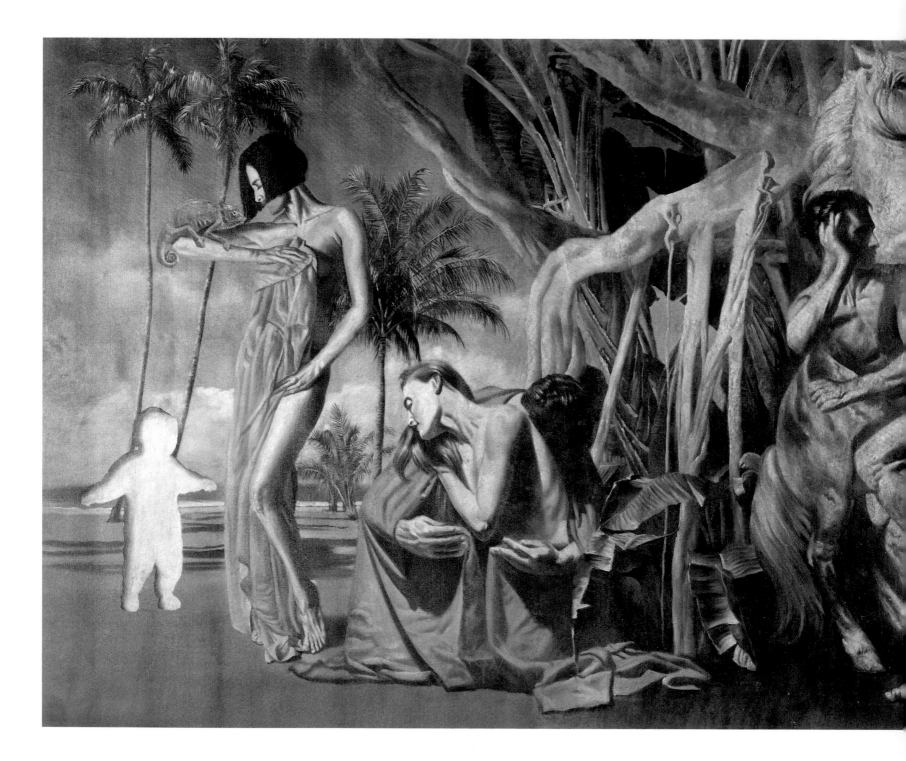

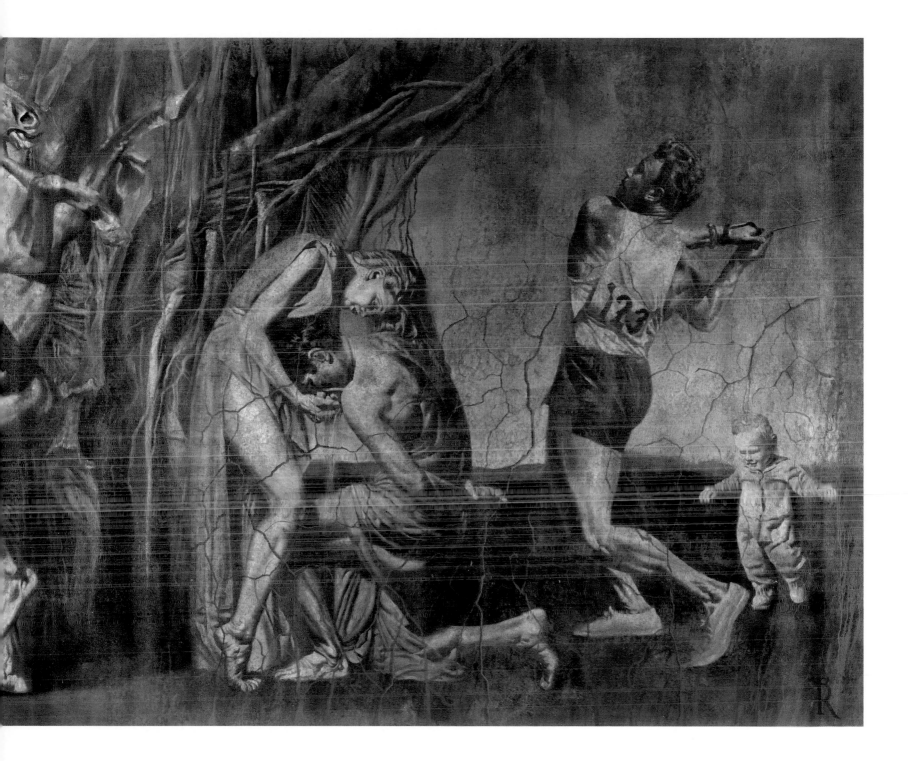

TRIBUTE TO MY FATHER, 2002, OIL ON CANVAS, 202 X 80 IN.

APUD SE, 2003, OIL ON CANVAS, 41 X 49 IN.

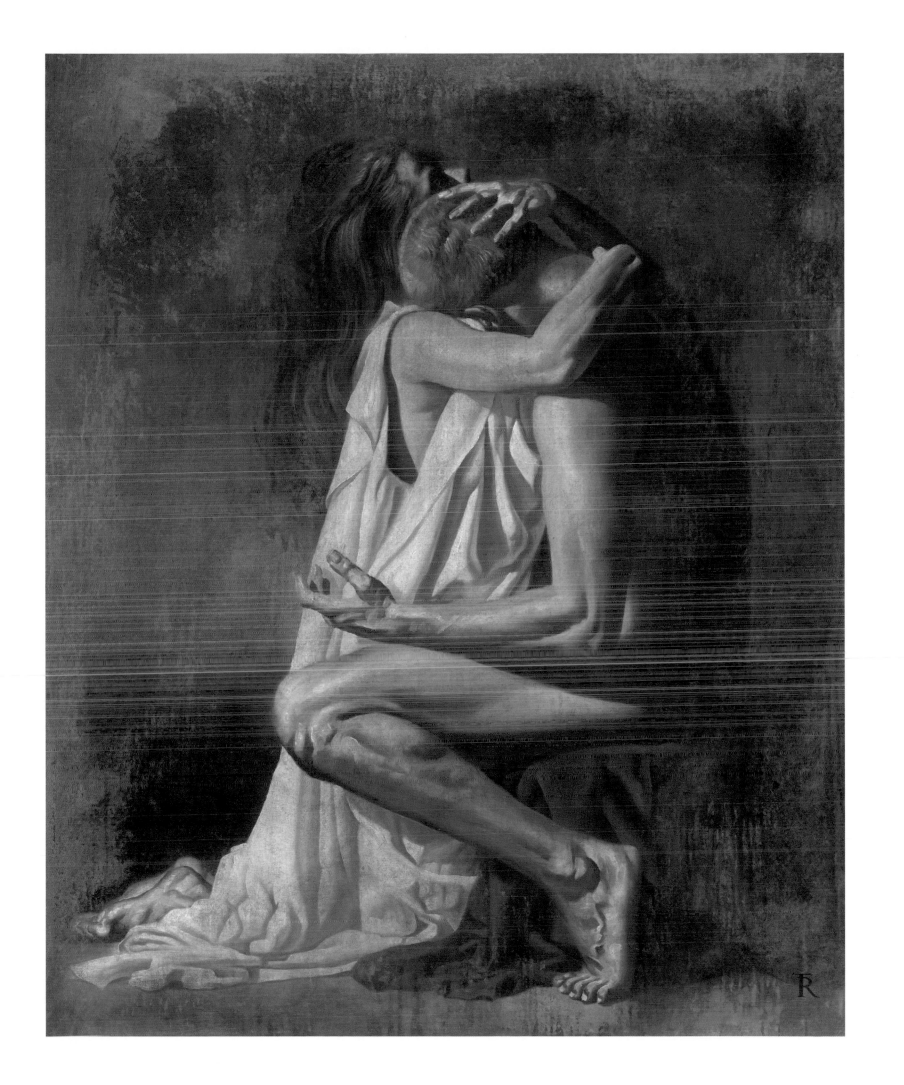

AUREIS, 2003, OIL ON CANVAS, 29 X 44 IN.

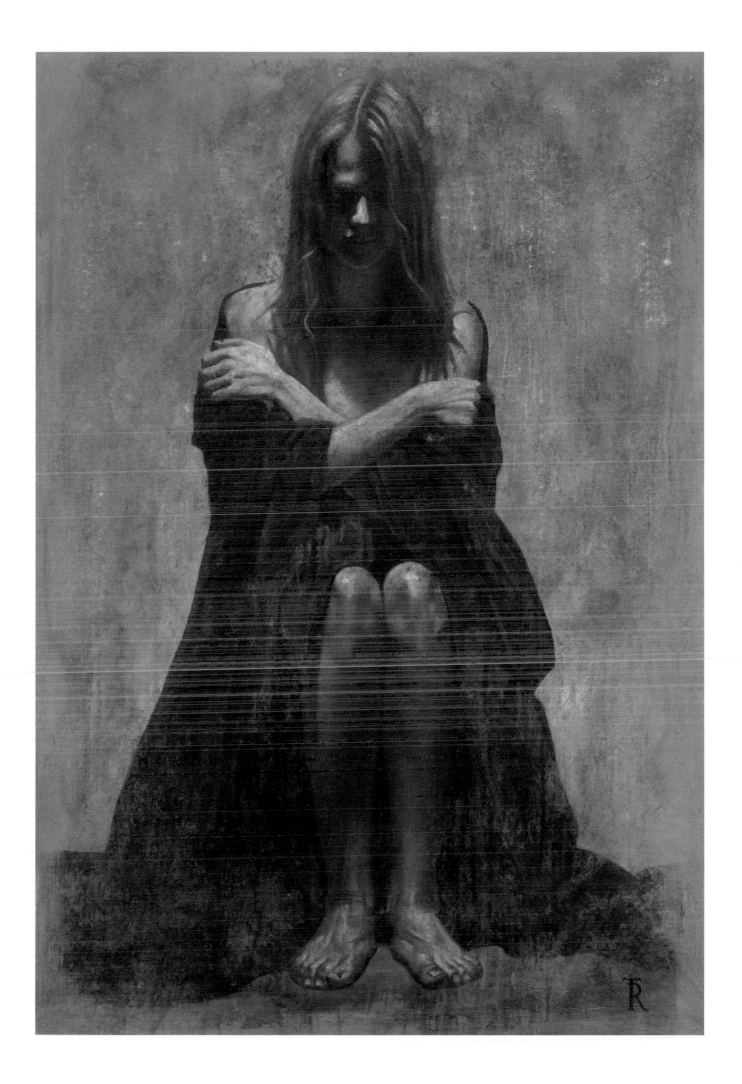

DIVINITAS II, 2003, OIL ON CANVAS, 50 X 63 IN.

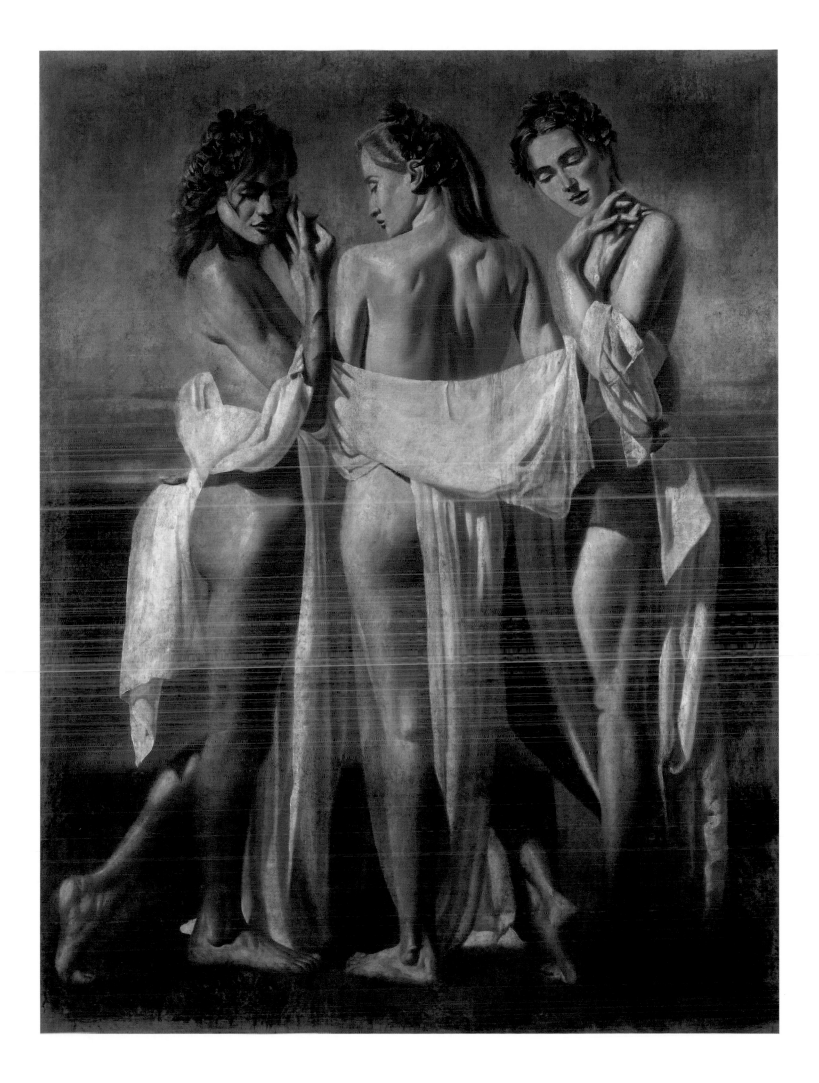

Ex Amo, 2003, OIL ON CANVAS, 47 X 50 IN.

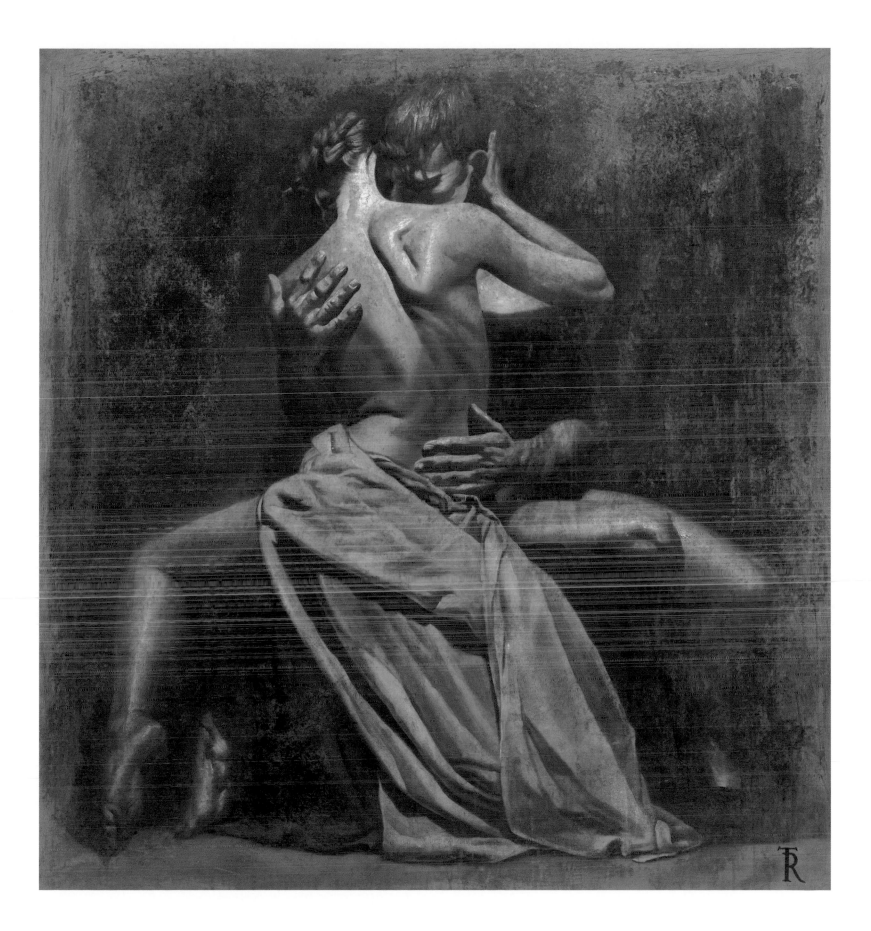

EX INTERNO, 2003, OIL ON CANVAS, 42 X 49 IN.

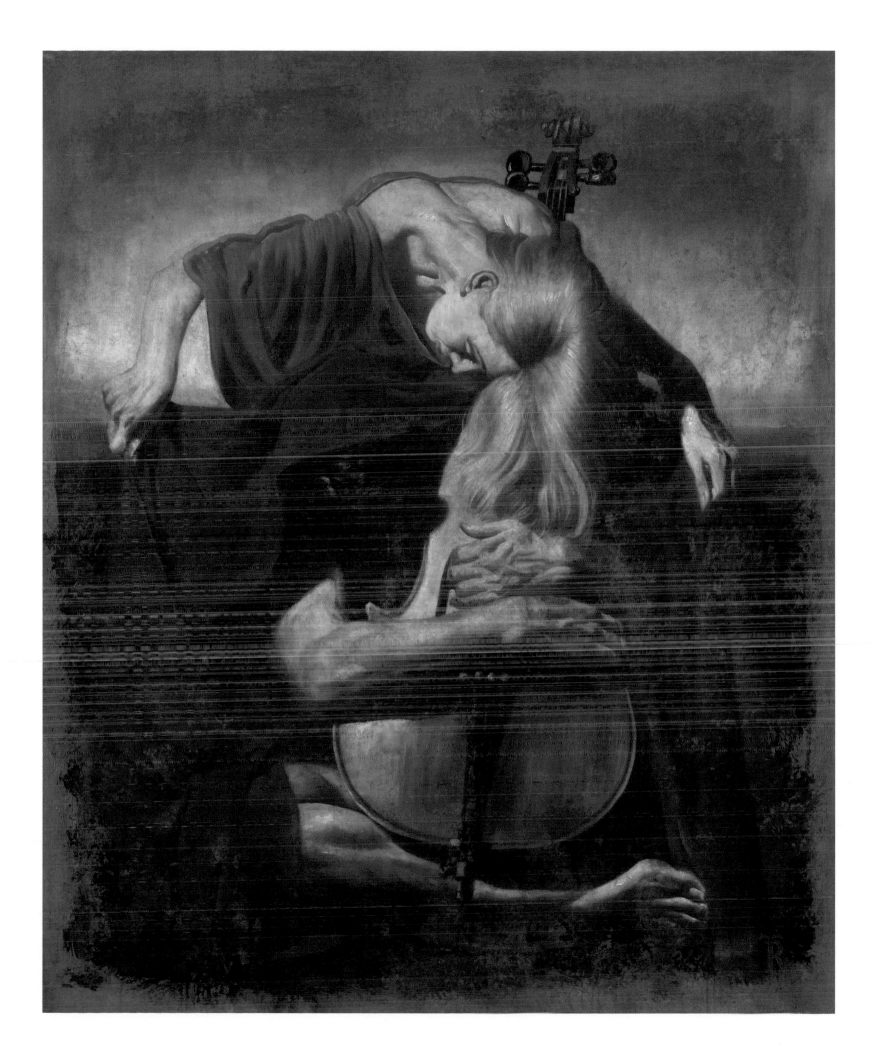

FIDICA, 2003, OIL ON CANVAS, 26 X 42 IN.

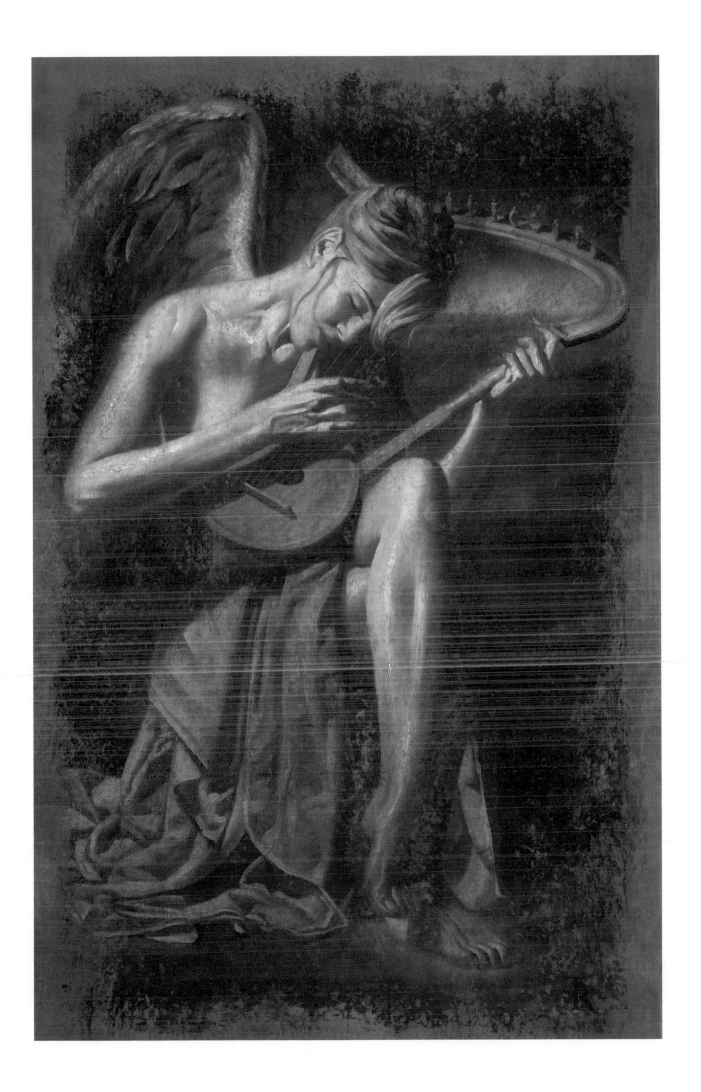

LEDA NOVA II, 2003, OIL ON CANVAS, 47 X 39 IN.

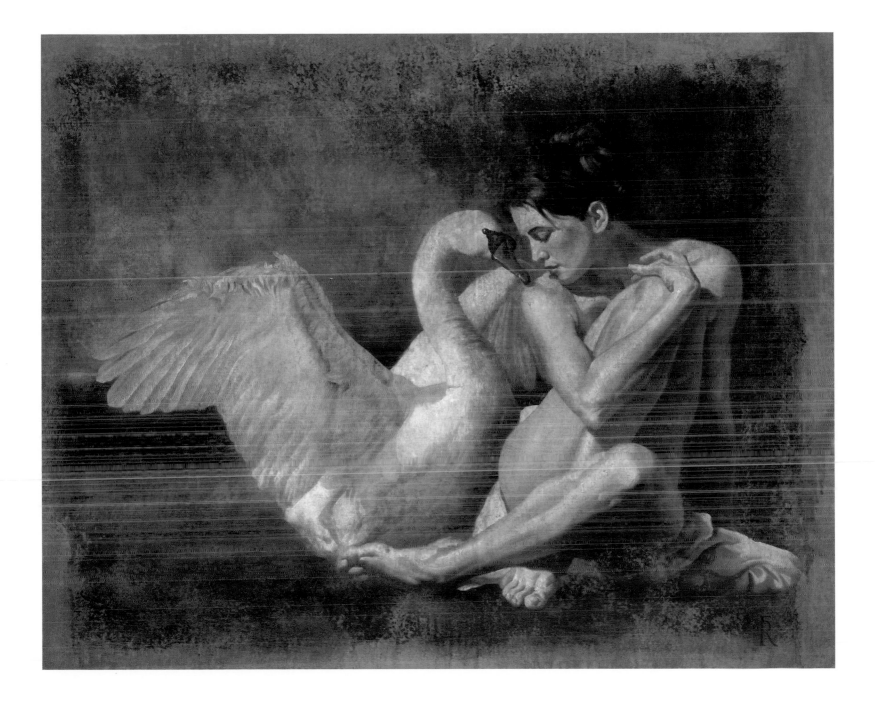

MISERERE, 2003, OIL ON CANVAS, 49 X 43 IN.

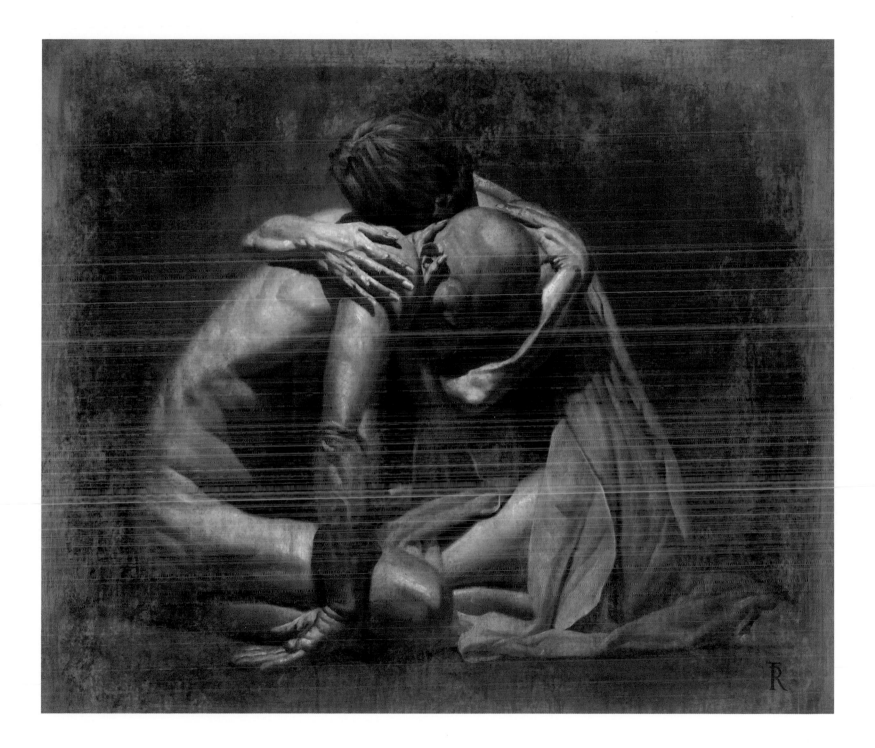

NAIDIS, 2003, OIL ON CANVAS, 33 x 48 IN.

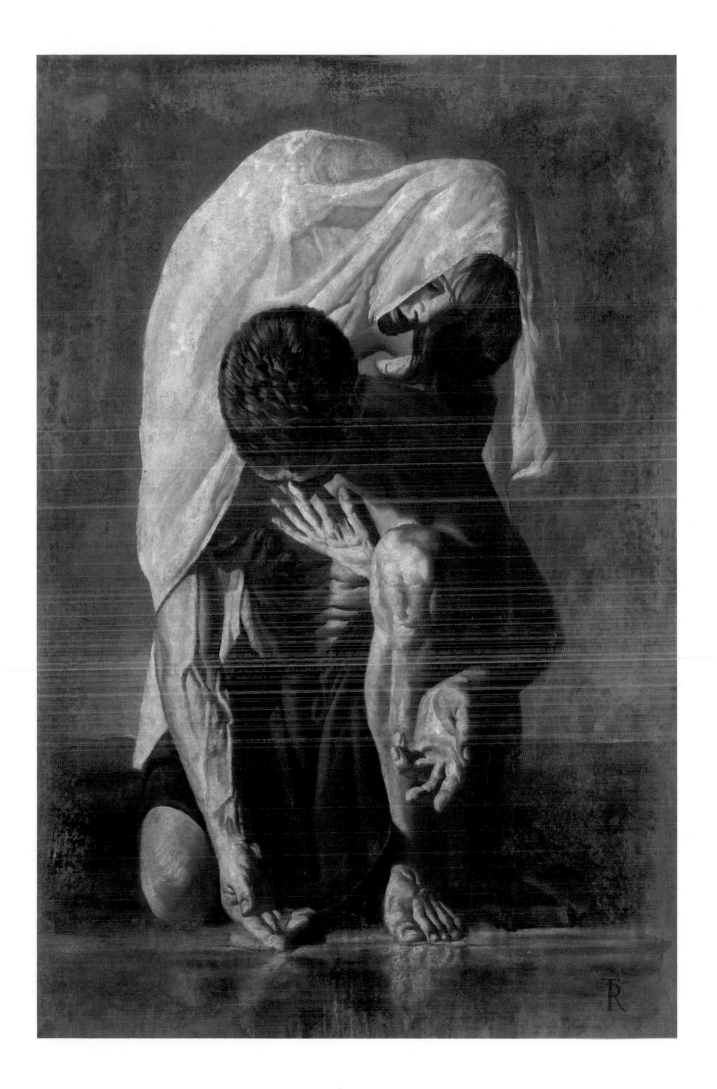

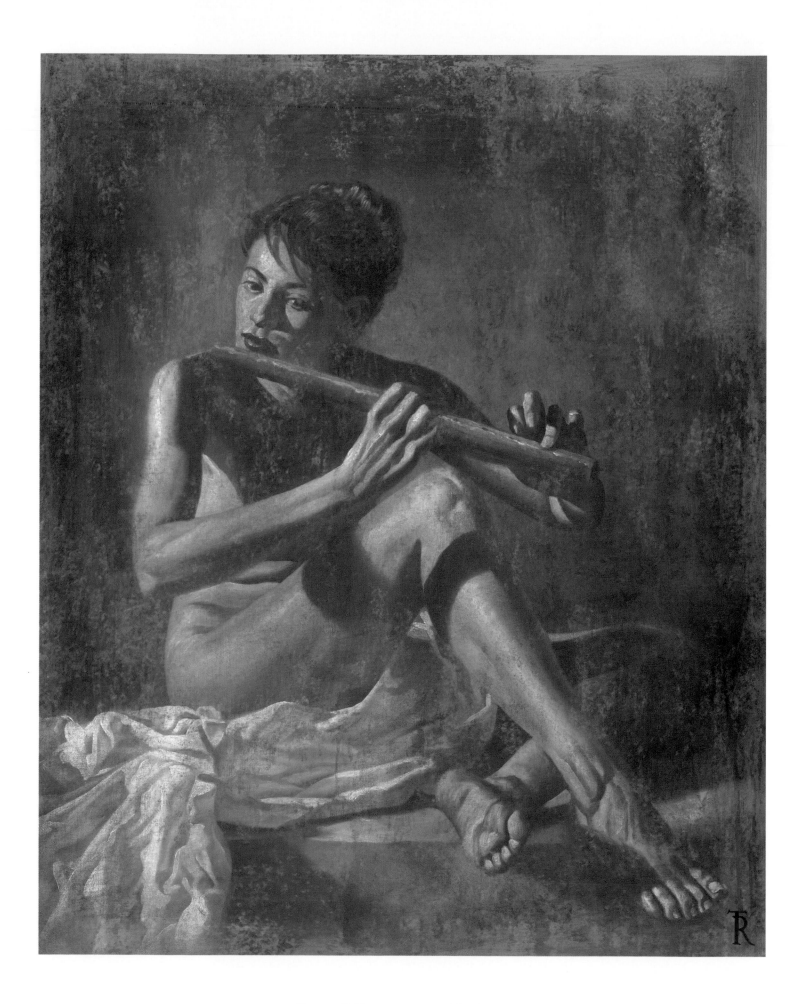

VIRDITA, 2003, OIL ON CANVAS, 34 x 41 IN.

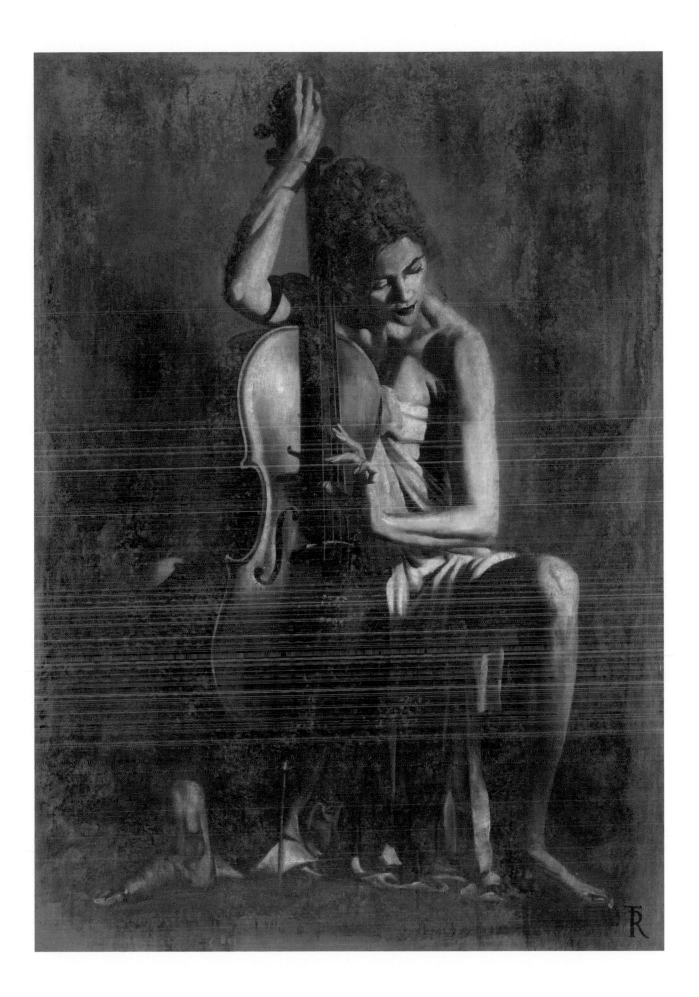

VOCALISA, 2003, OIL ON CANVAS, 36 x 48 IN.

AL FINE, 2004, OIL ON CANVAS, 50 X 60 IN.

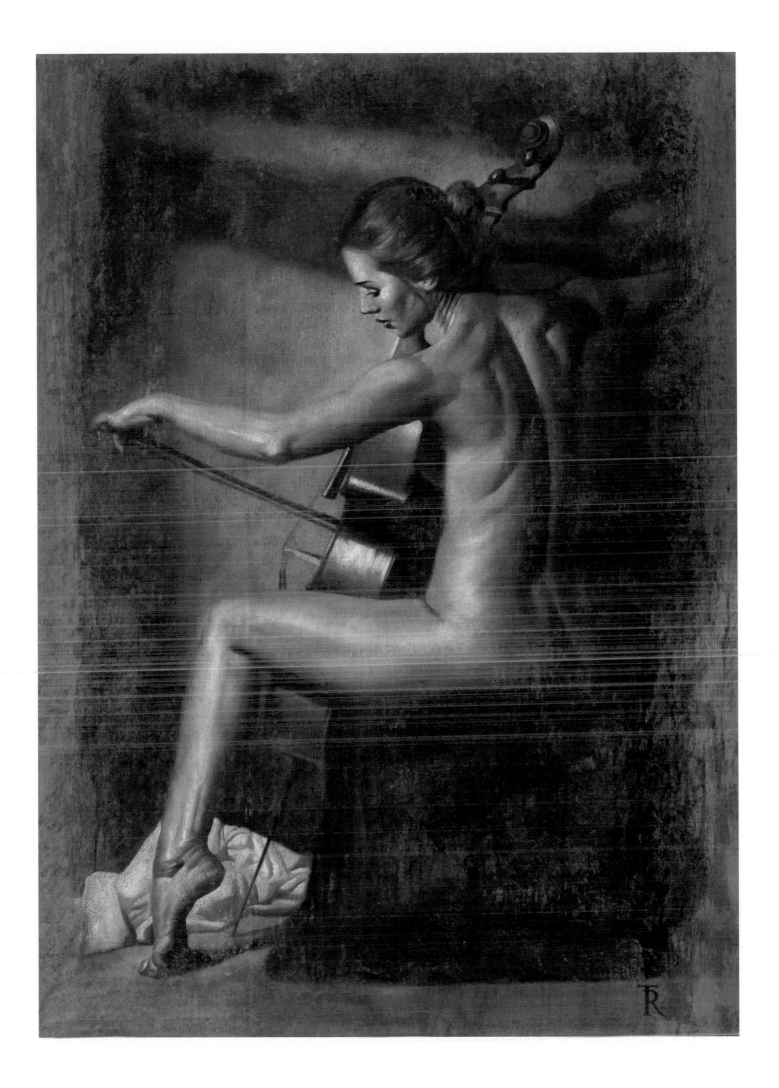

AENEICA, 2004, OIL ON CANVAS, 29 X 43 IN.

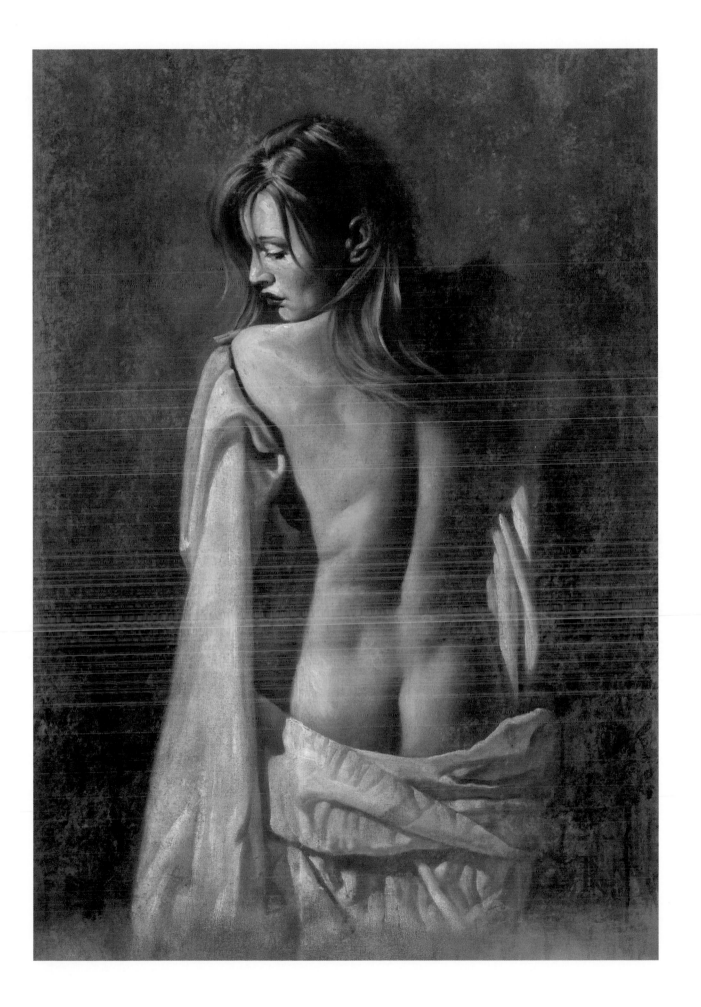

ALMABILIS, 2004, OIL ON CANVAS, 40 X 50 IN.

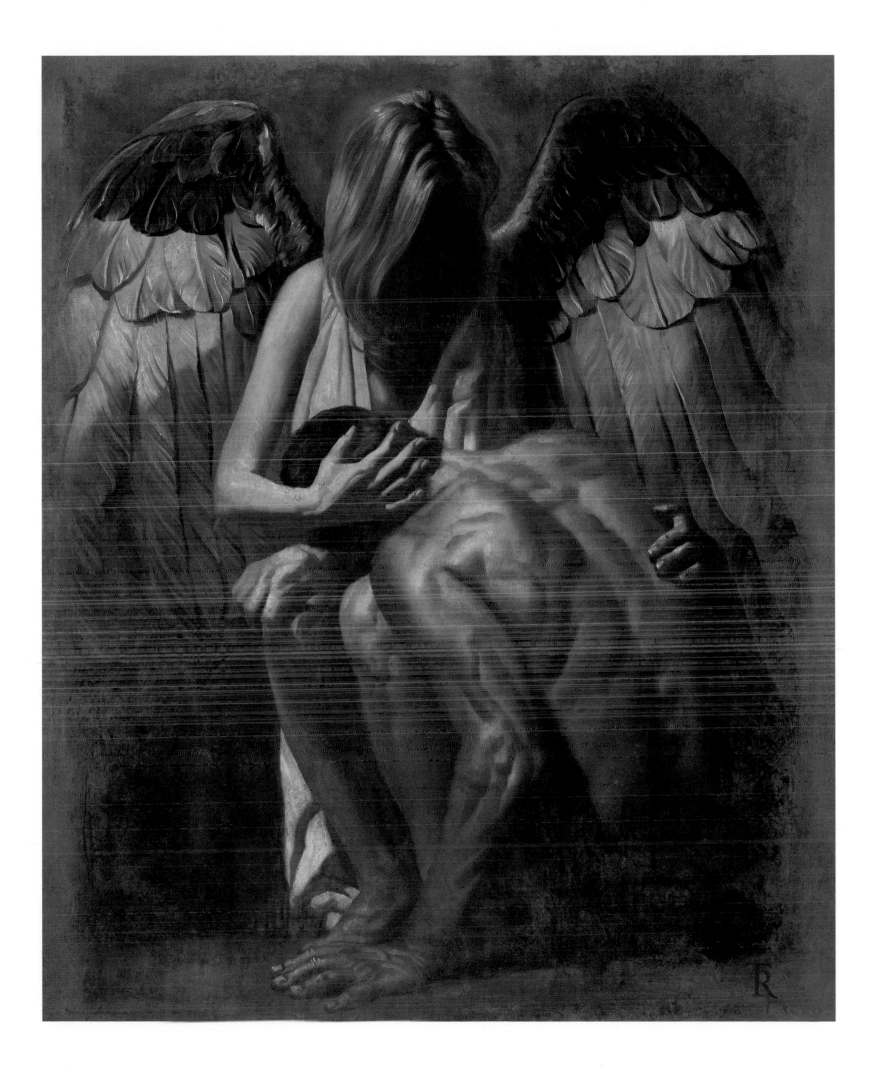

CLARITA, 2004, OIL ON CANVAS, 30 X 40 IN.

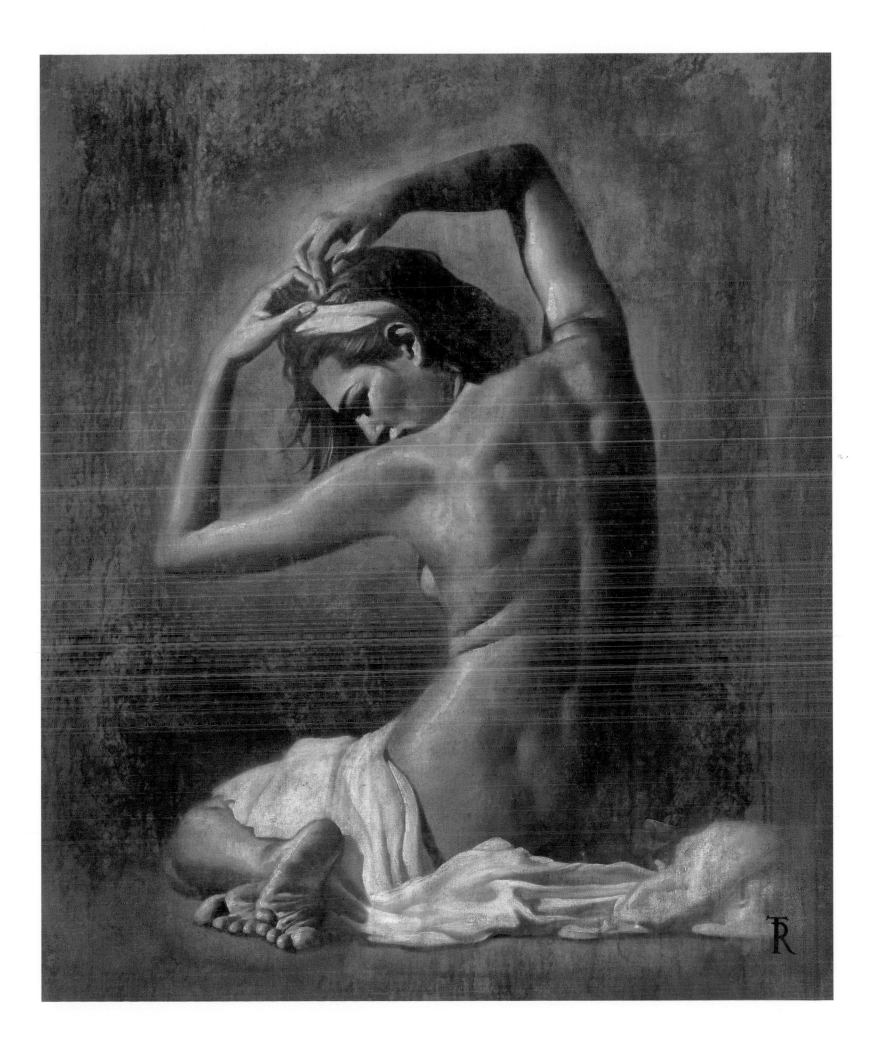

EOLIS, 2004, OIL ON CANVAS, 29 X 39 IN.

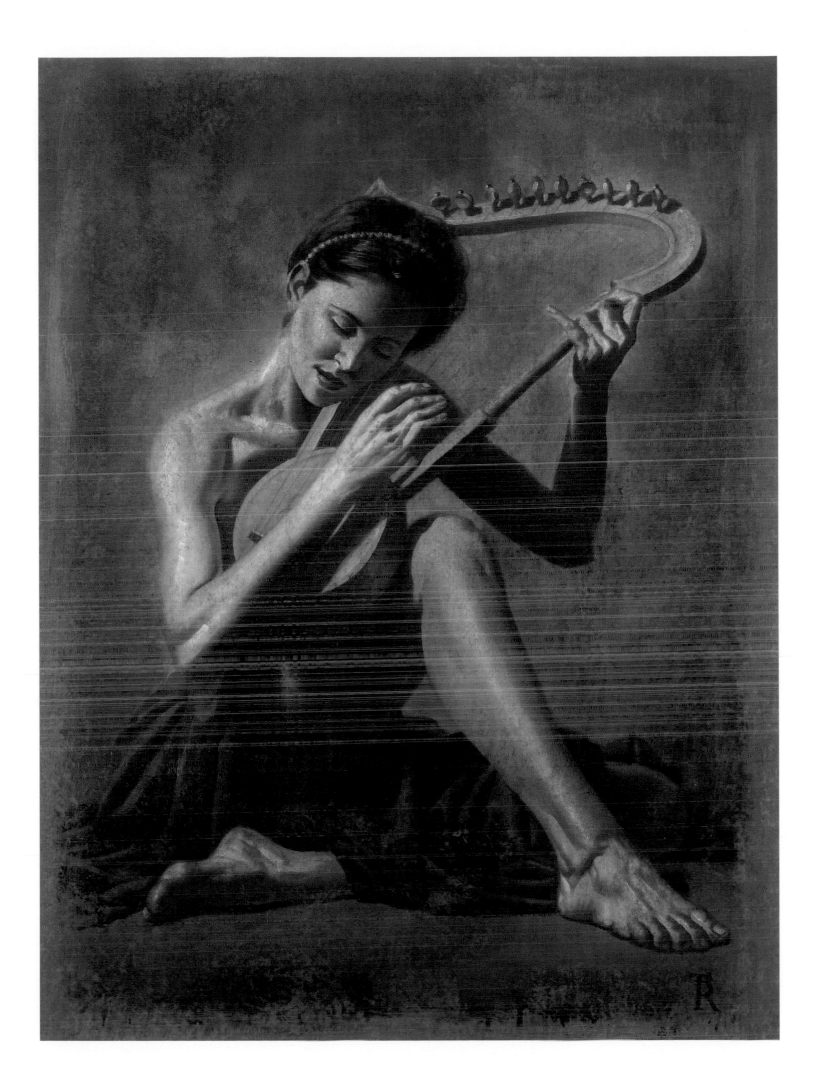

LUCIDA, 2004, OIL ON CANVAS, 65 X 44 IN.

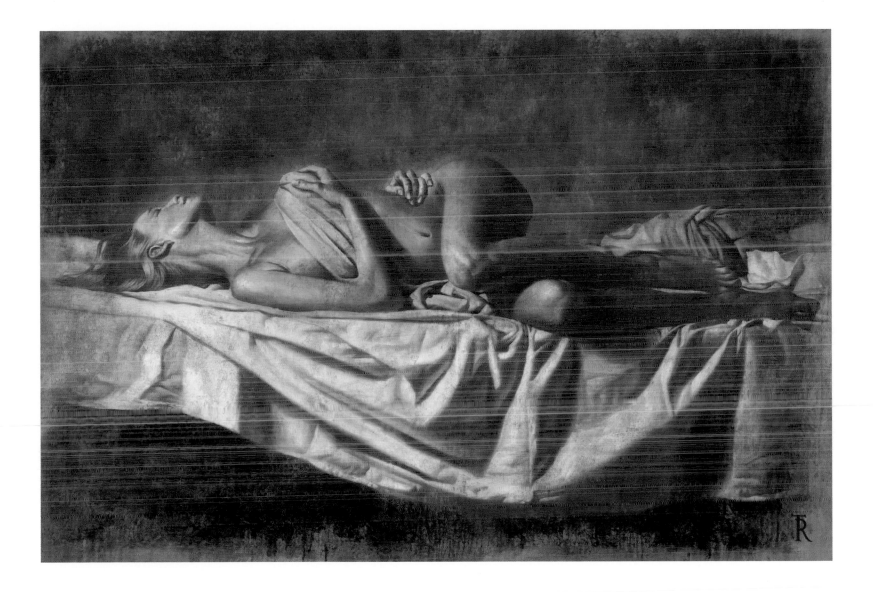

In Ascendo, 2004, oil on canvas, 46 x 68 in.

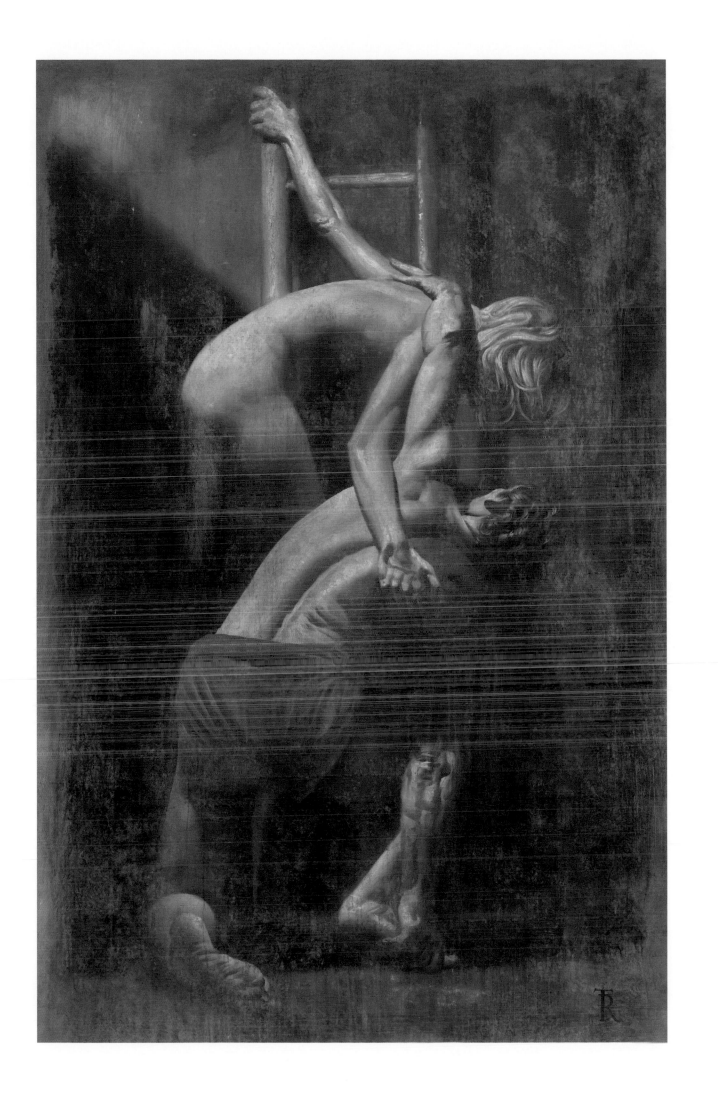

KORA, 2004, OIL ON CANVAS, 31 X 50 IN.

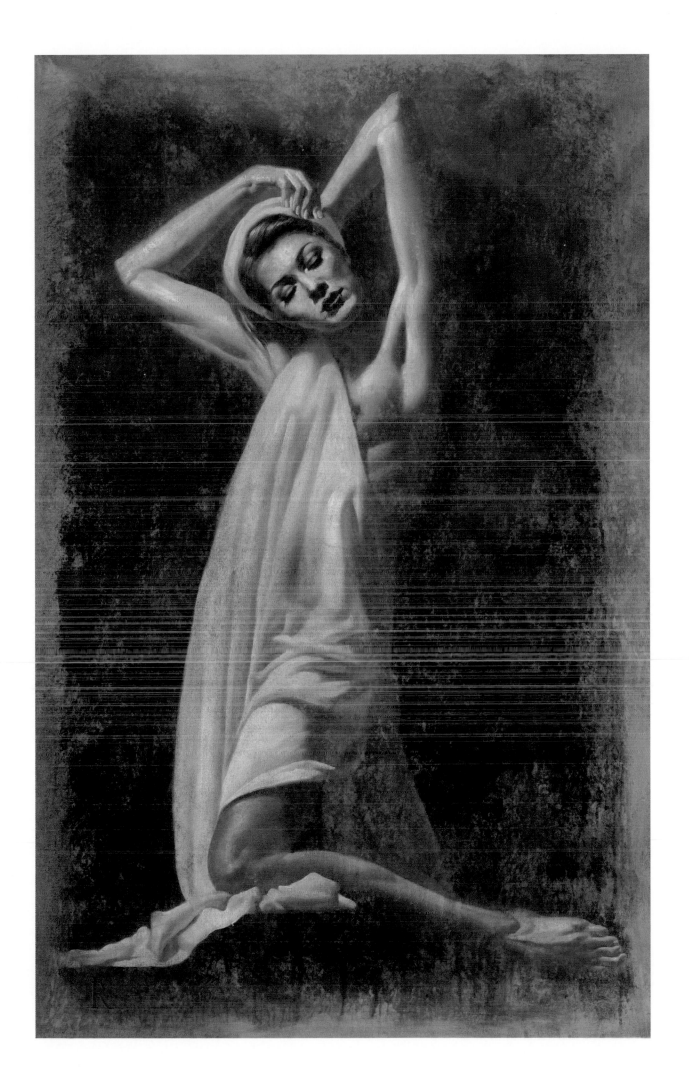

SCIOLTO, 2004, OIL ON CANVAS, 35 X 50 IN.

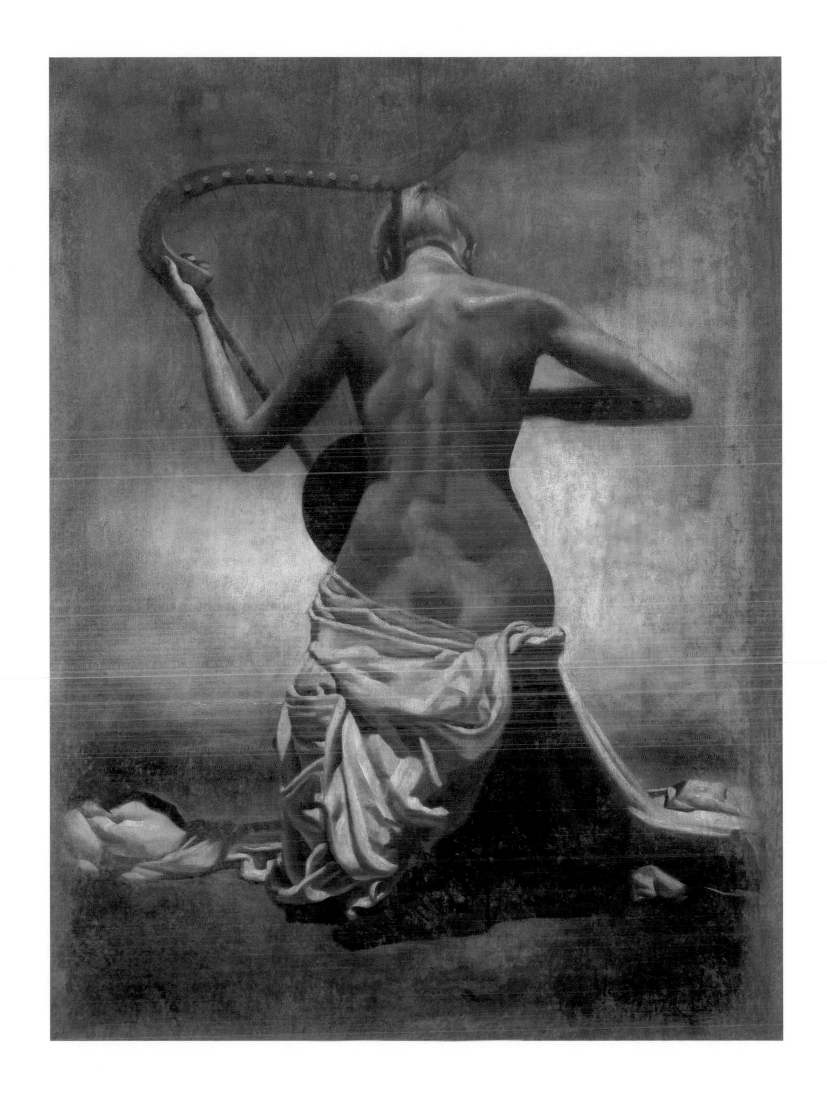

TENACIS, 2004, OIL ON CANVAS, 48 X 60 IN.

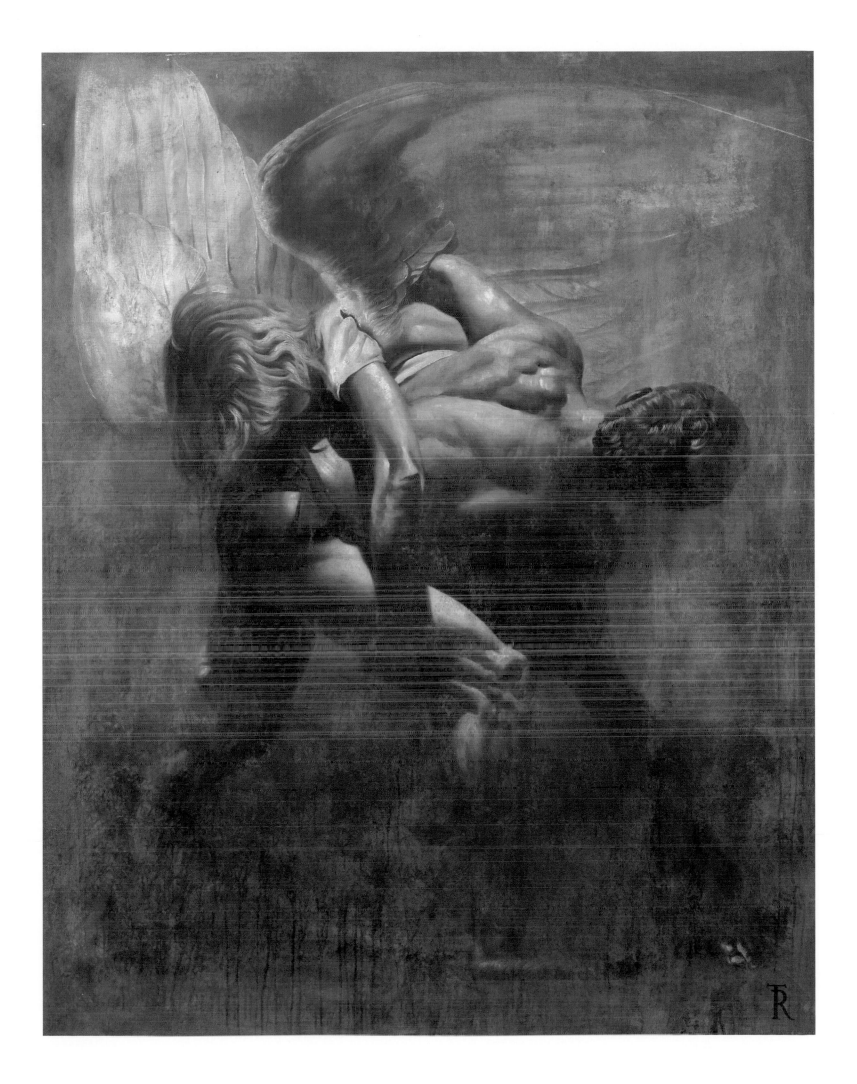

TENTATIS, 2004, OIL ON CANVAS, 25 X 37 IN.

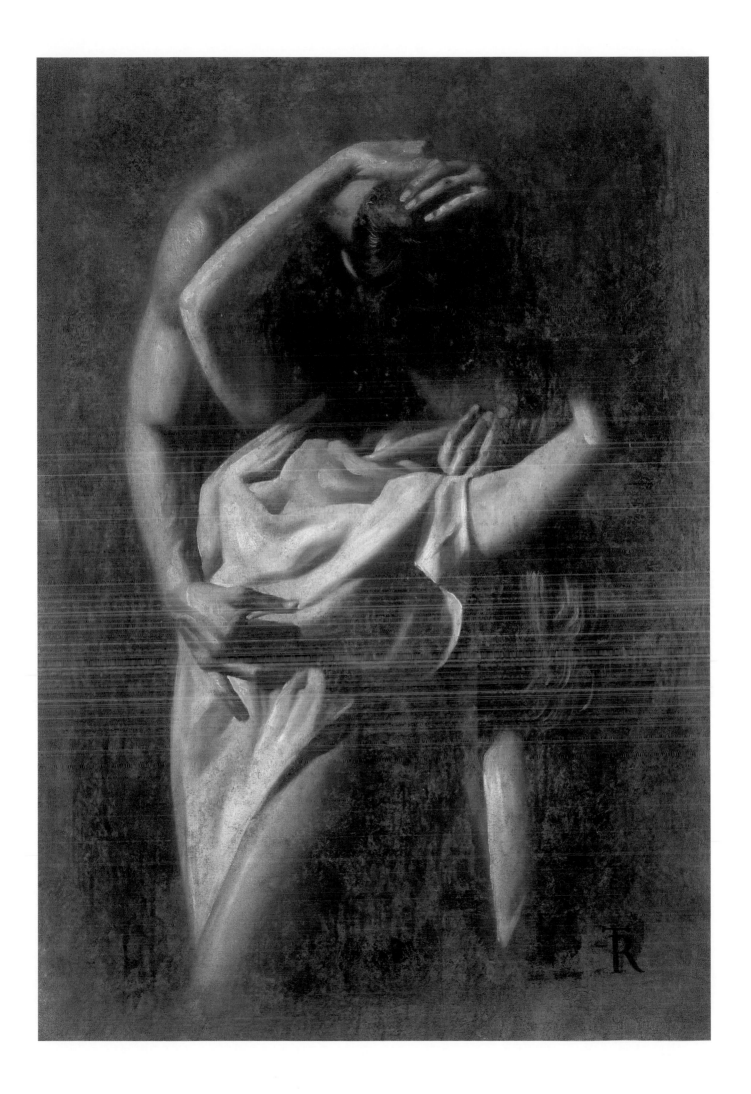

BONA DEA, 2005, OIL ON CANVAS, 45 X 49 IN.

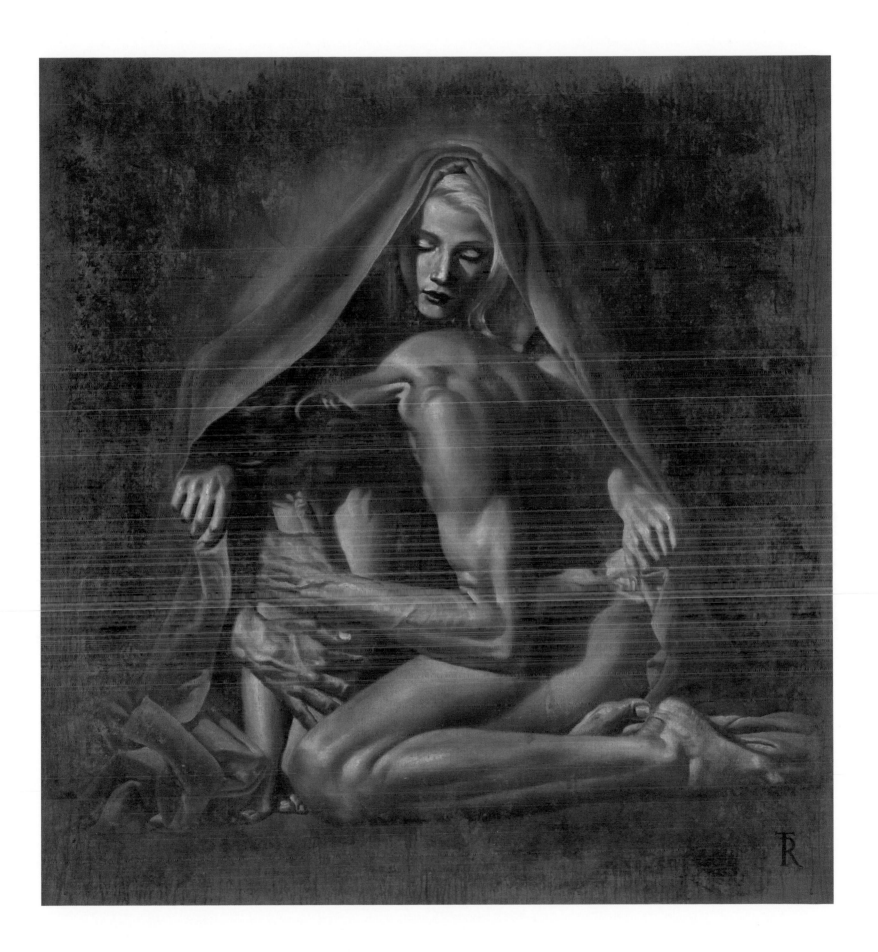

CANTILENA, 2005, OIL ON CANVAS, 33 X 48 IN.

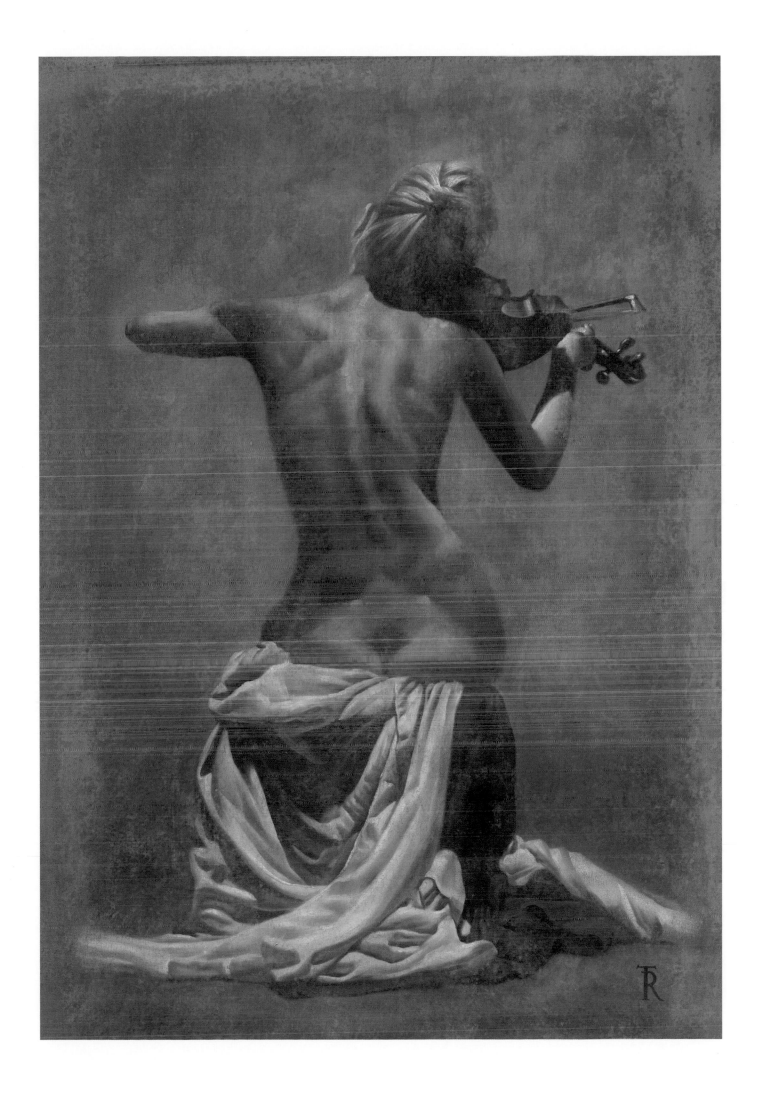

CARISSIMA, 2005, OIL ON CANVAS, 38 X 48 IN.

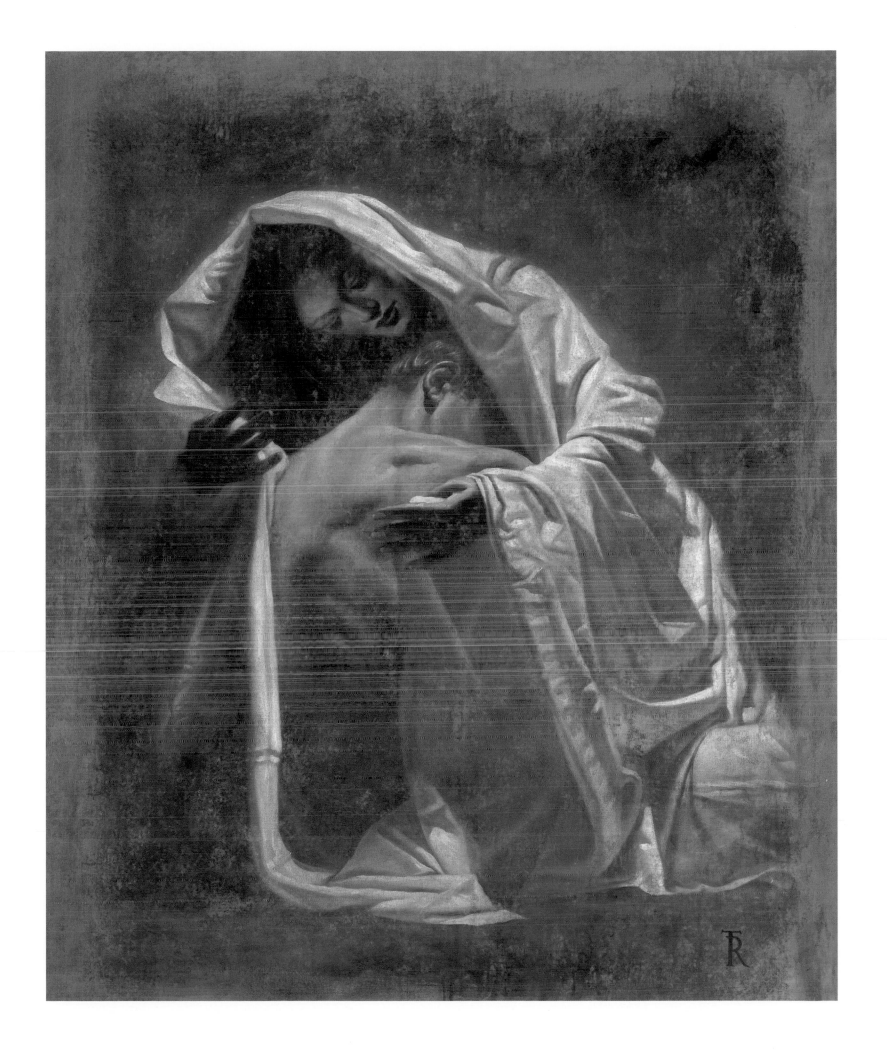

CHRYSALIS, 2005, OIL ON CANVAS, 40 X 60 IN.

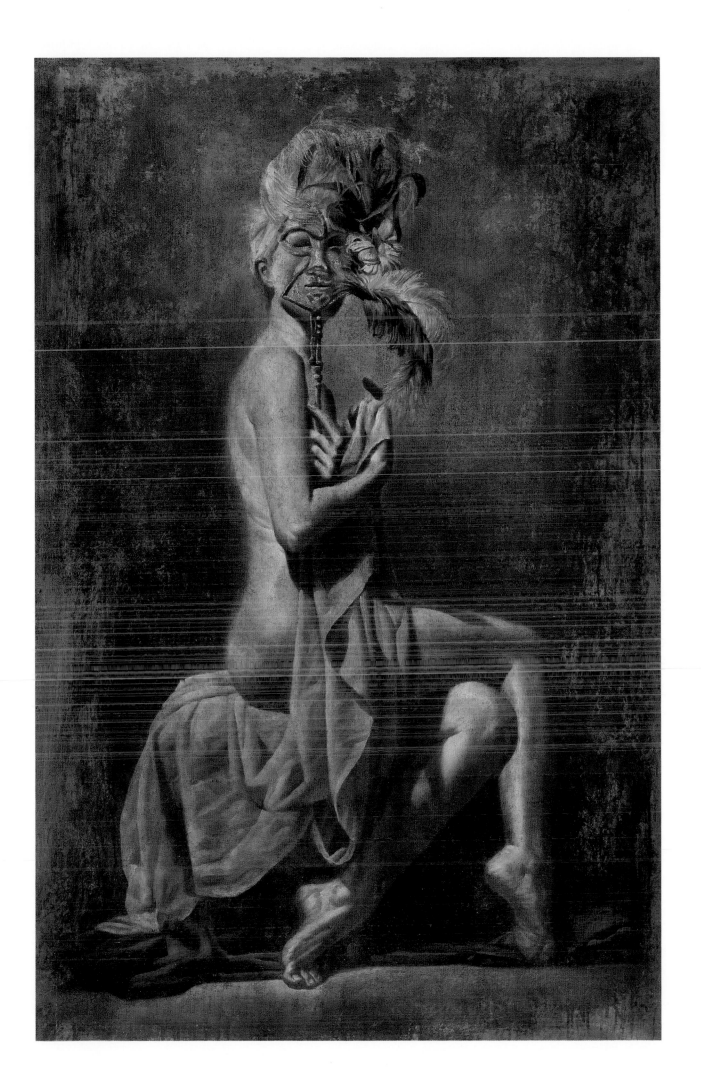

DIMINUENDO, 2005, OIL ON CANVAS, 46 X 64 IN.

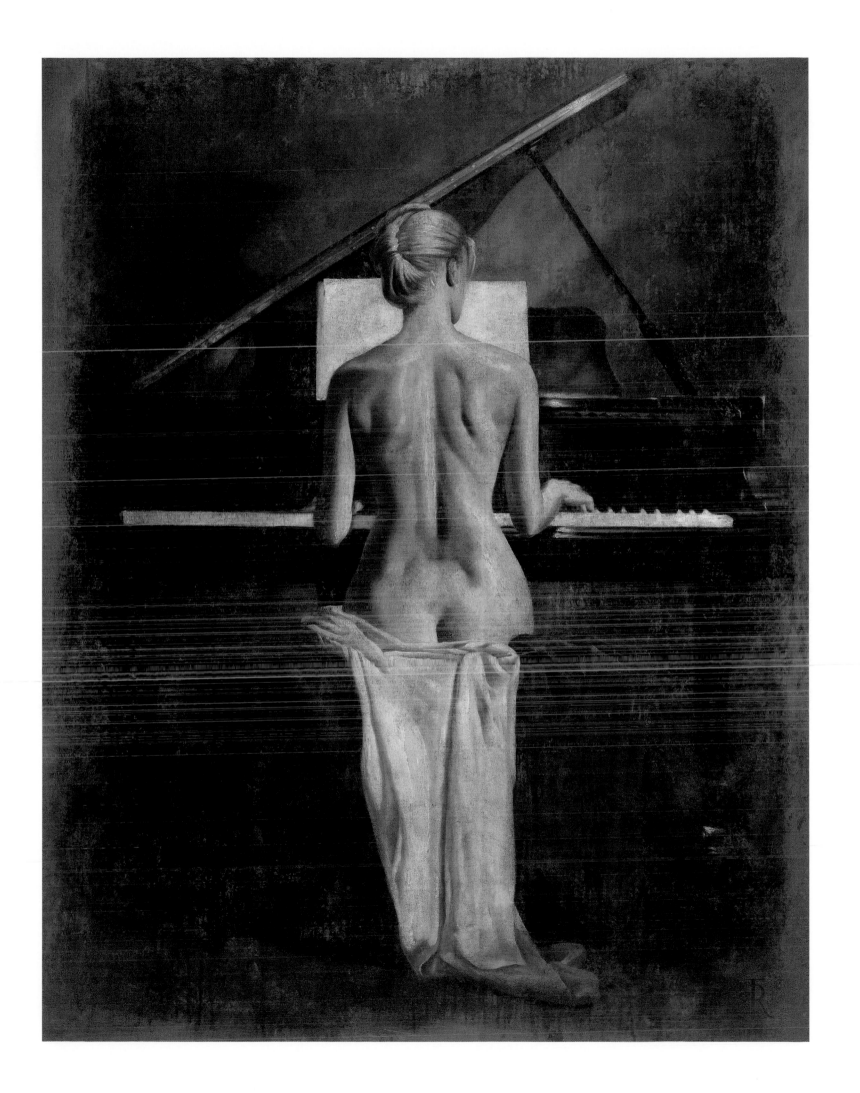

EX CRUCE, 2005, OIL ON CANVAS, 86 X 58 IN.

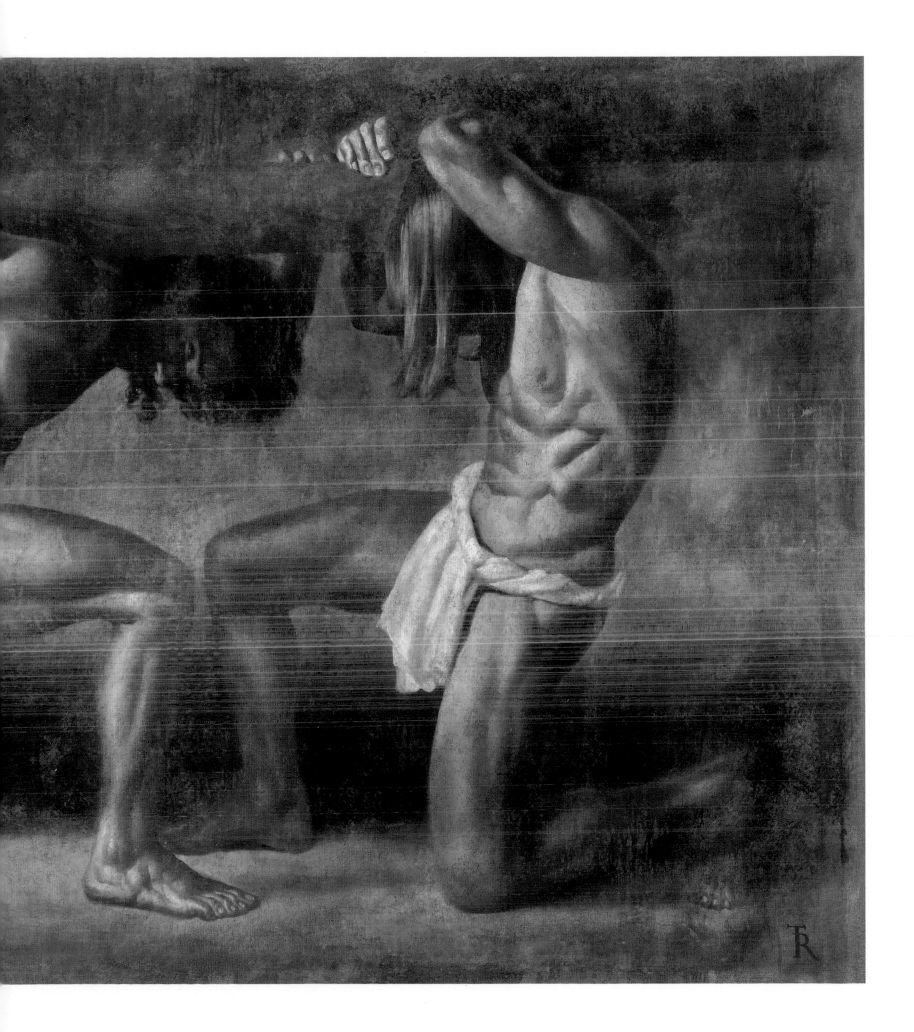

EX QUERO, 2005, OIL ON CANVAS, 43 X 49 IN.

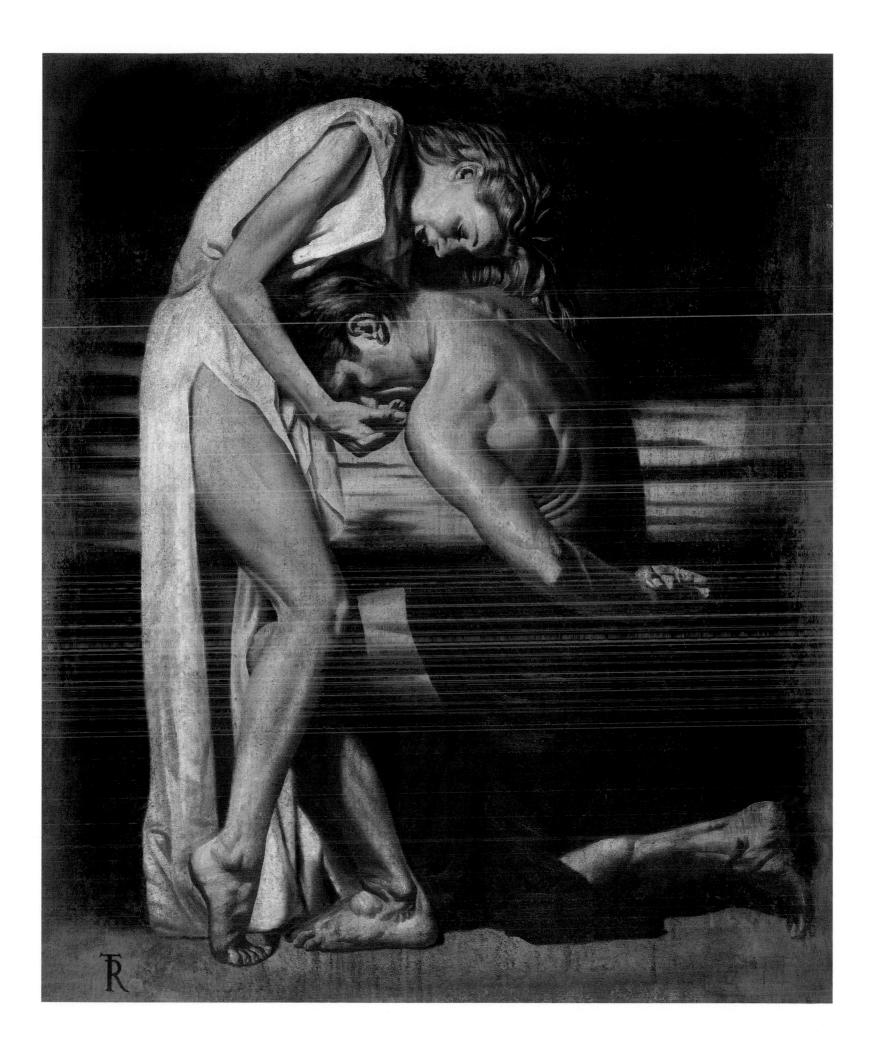

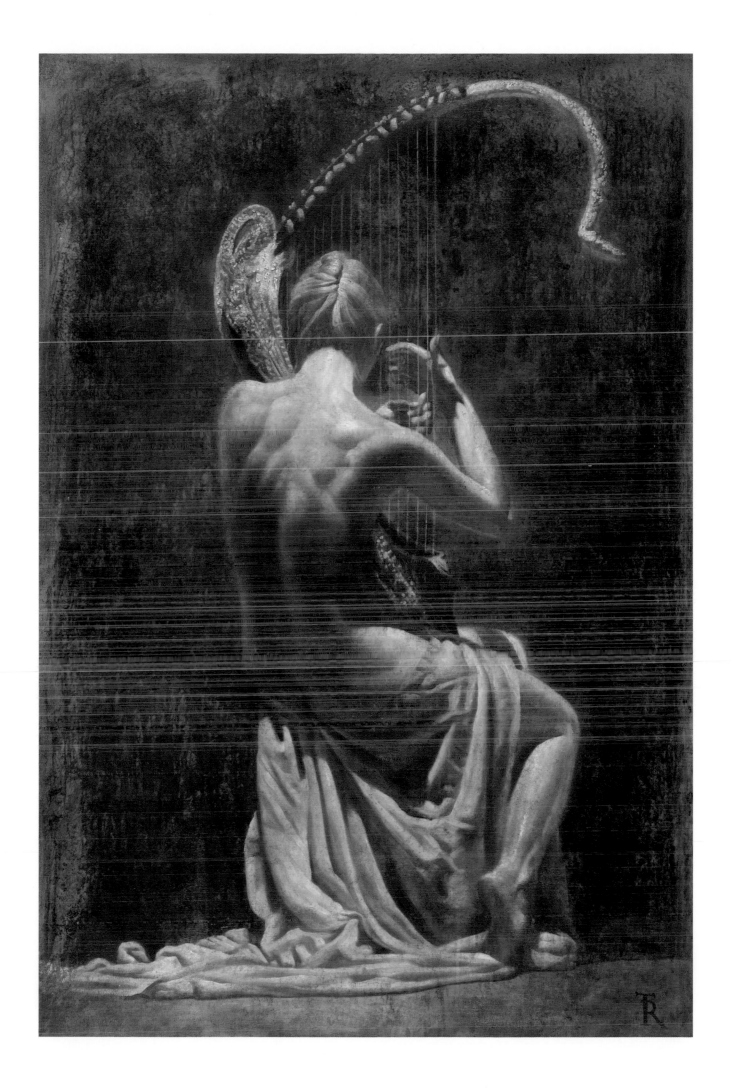

FLORIS, 2005, OIL ON CANVAS, 36 X 51 IN.

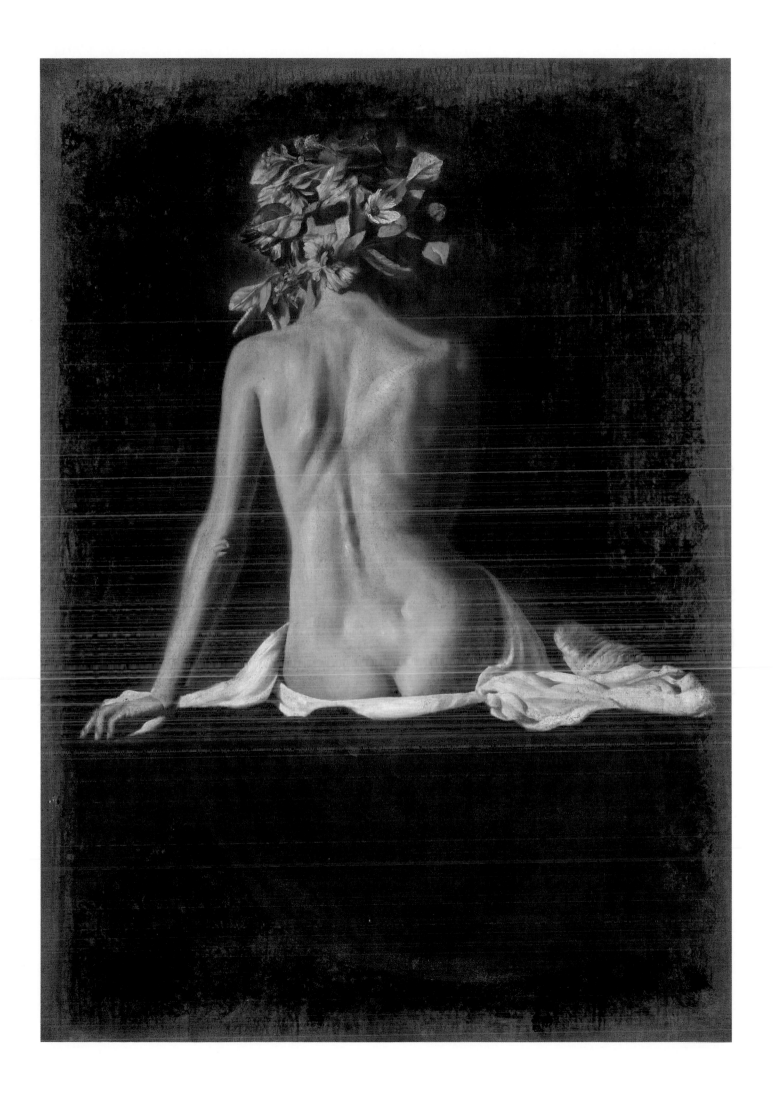

ORATORIO, 2005, OIL ON CANVAS, 40 X 50 IN.

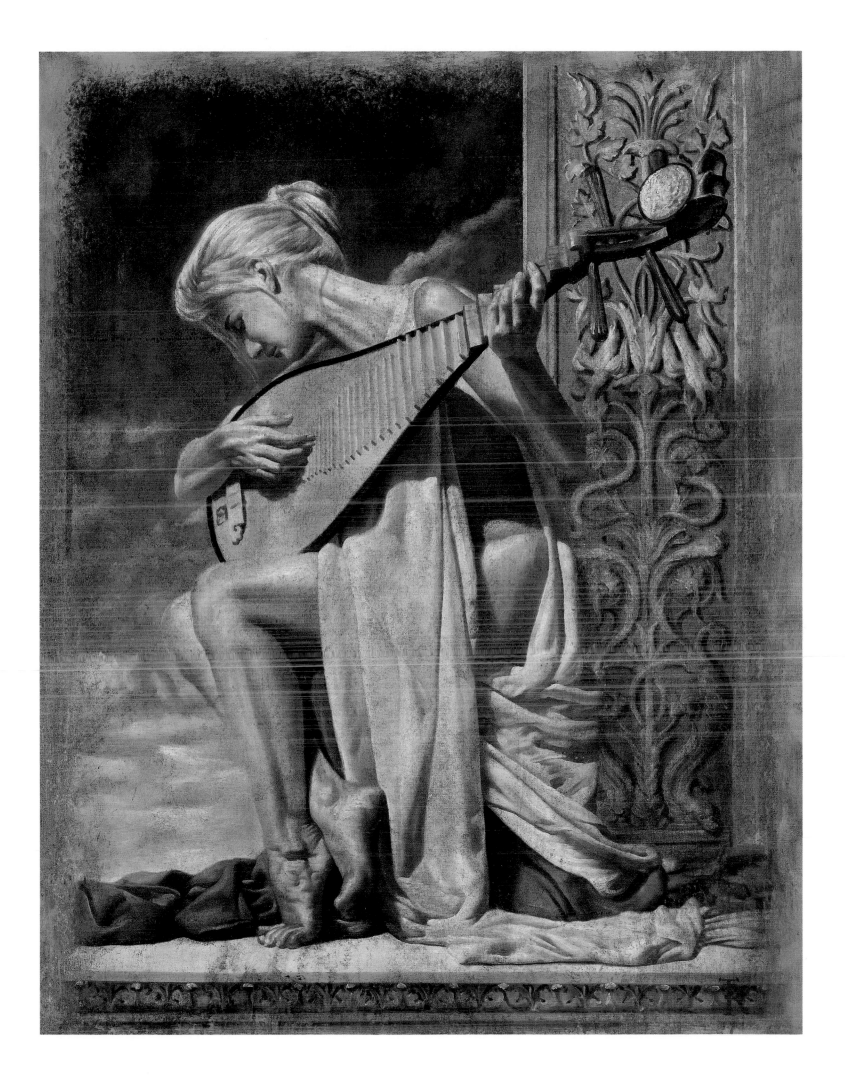

ORPHEIS, 2005, OIL ON CANVAS, 62 X 58 IN.

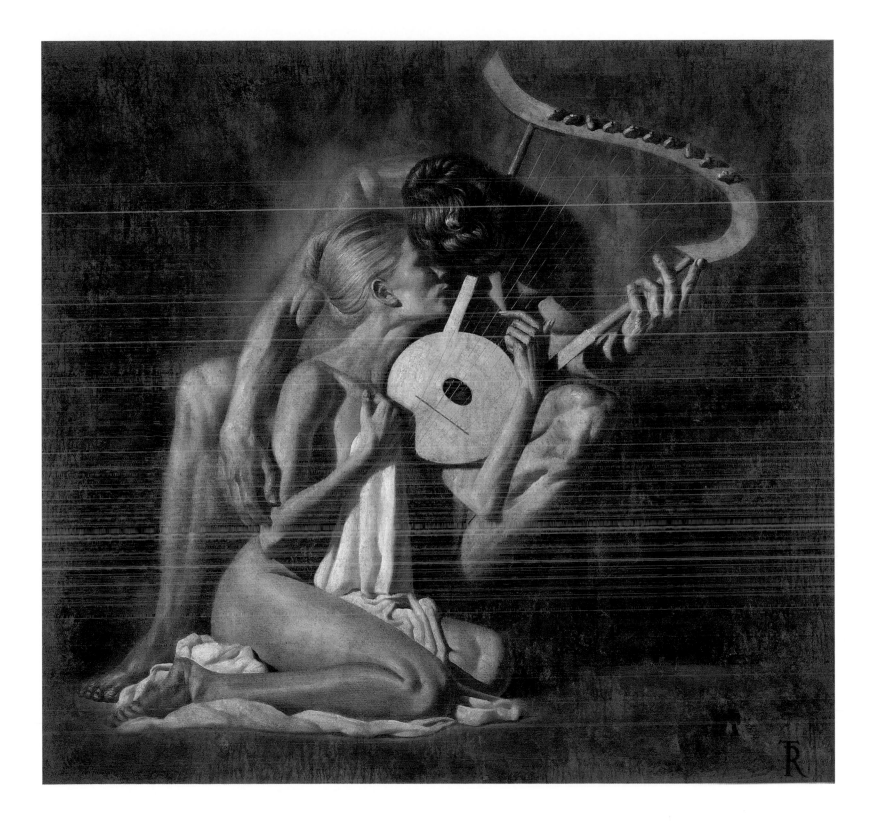

ROSA, 2005, OIL ON CANVAS, 33 X 47 IN.

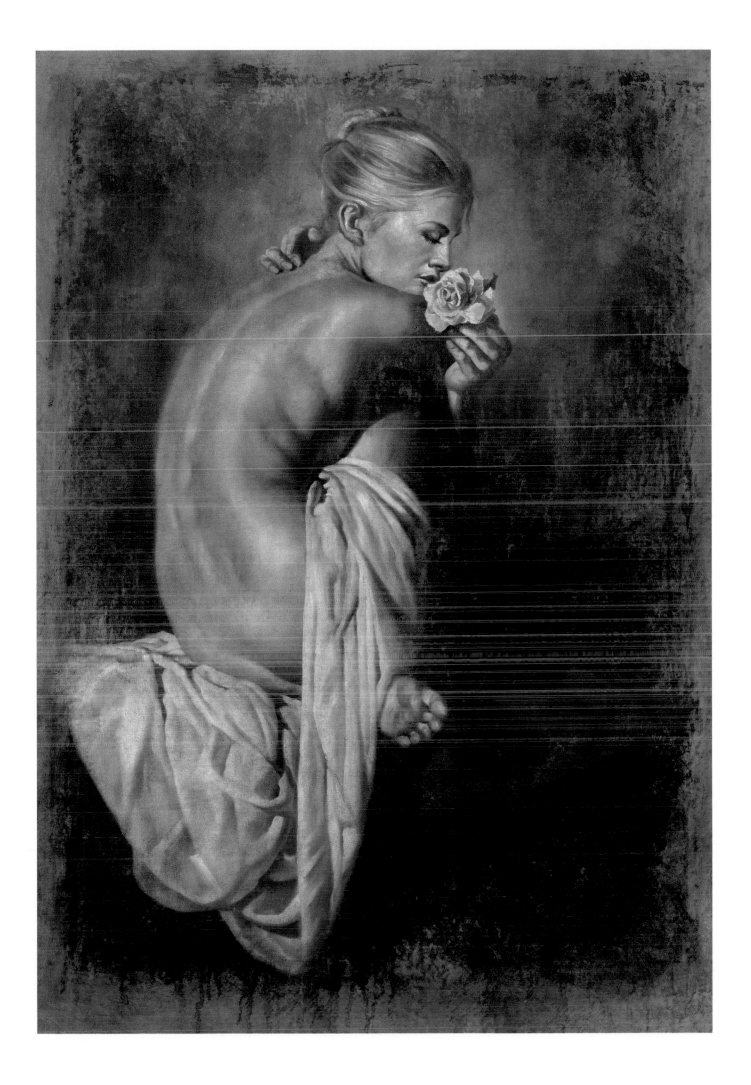

SI VERO, 2005, OIL ON CANVAS, 45 X 45 IN.

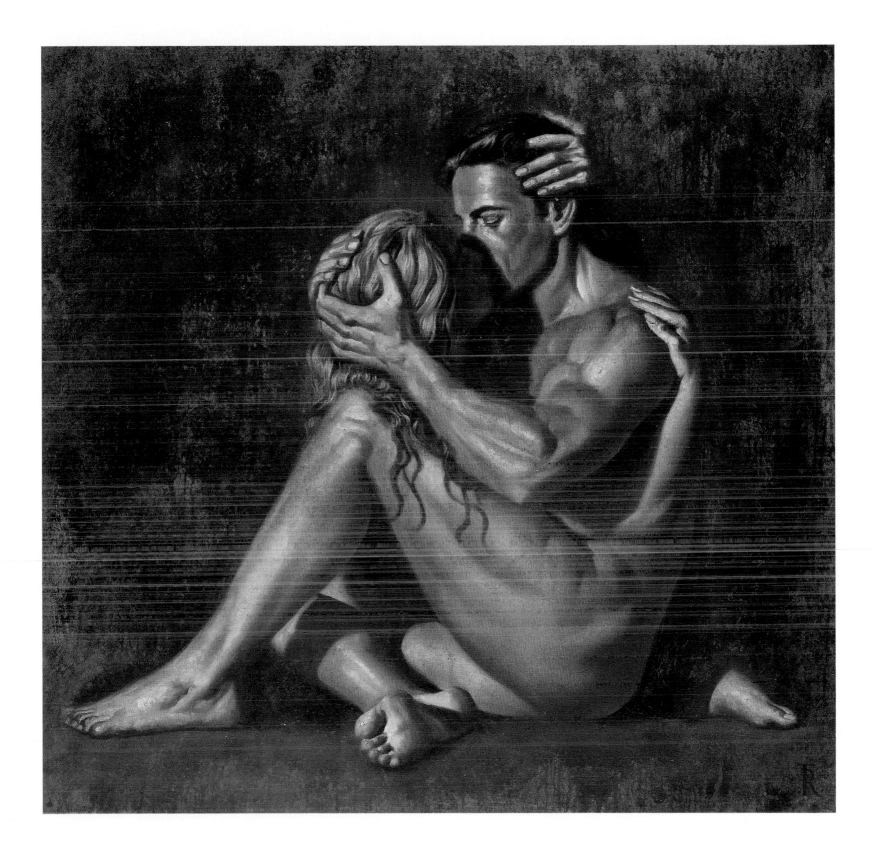

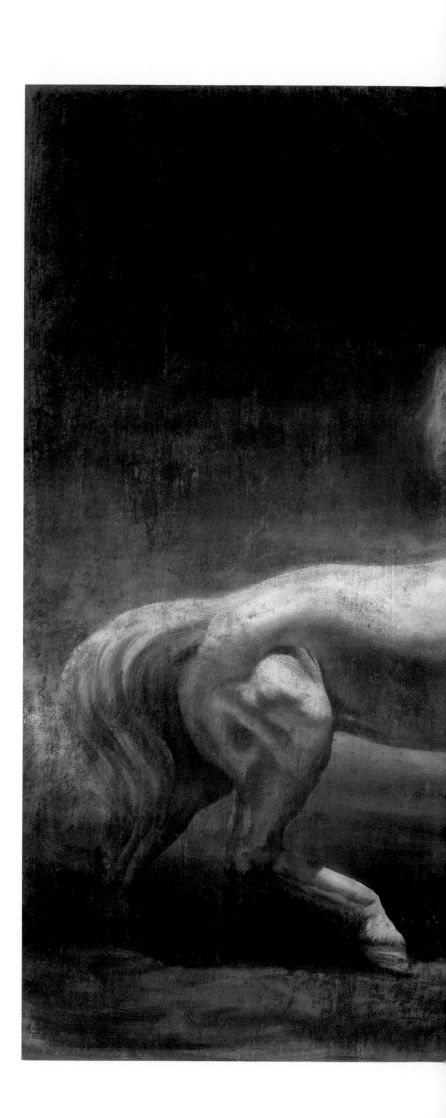

TEMPESTAS, 2005, OIL ON CANVAS, 108 X 79 IN.

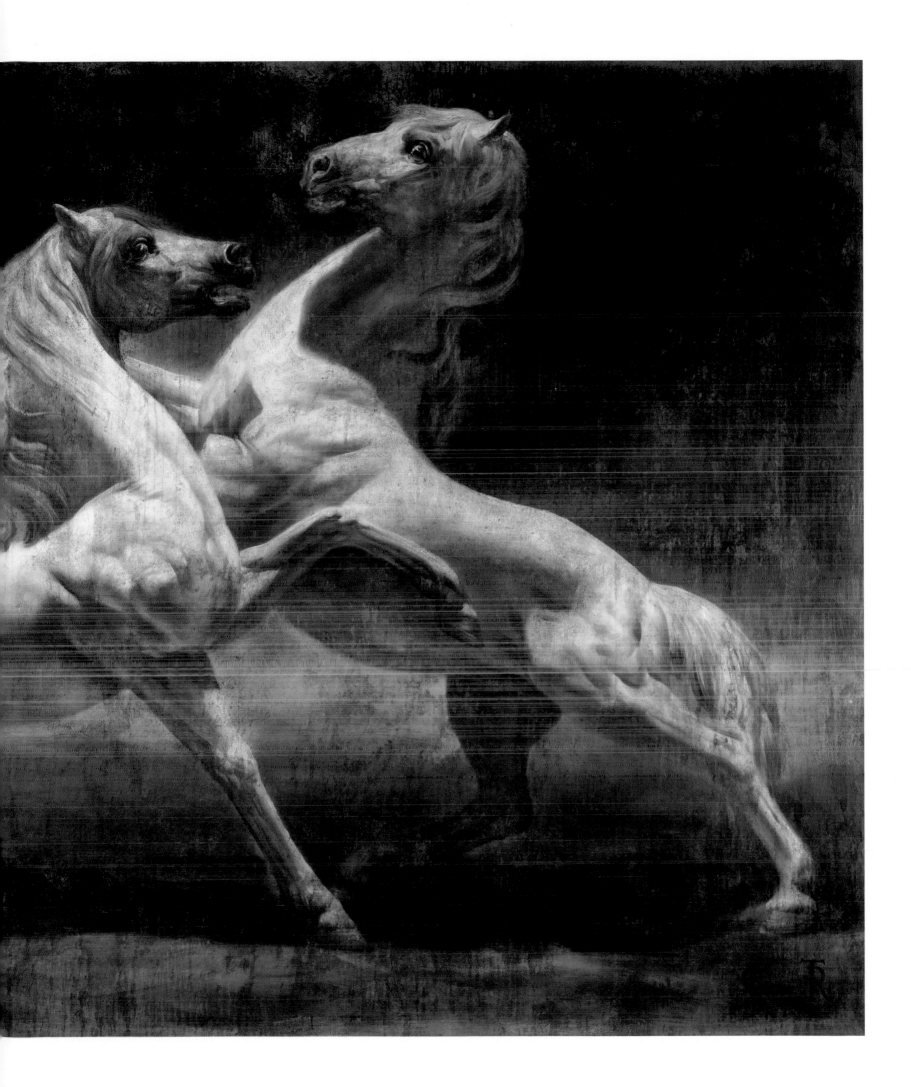

TYRIS, 2005, OIL ON CANVAS, 29 X 45 IN.

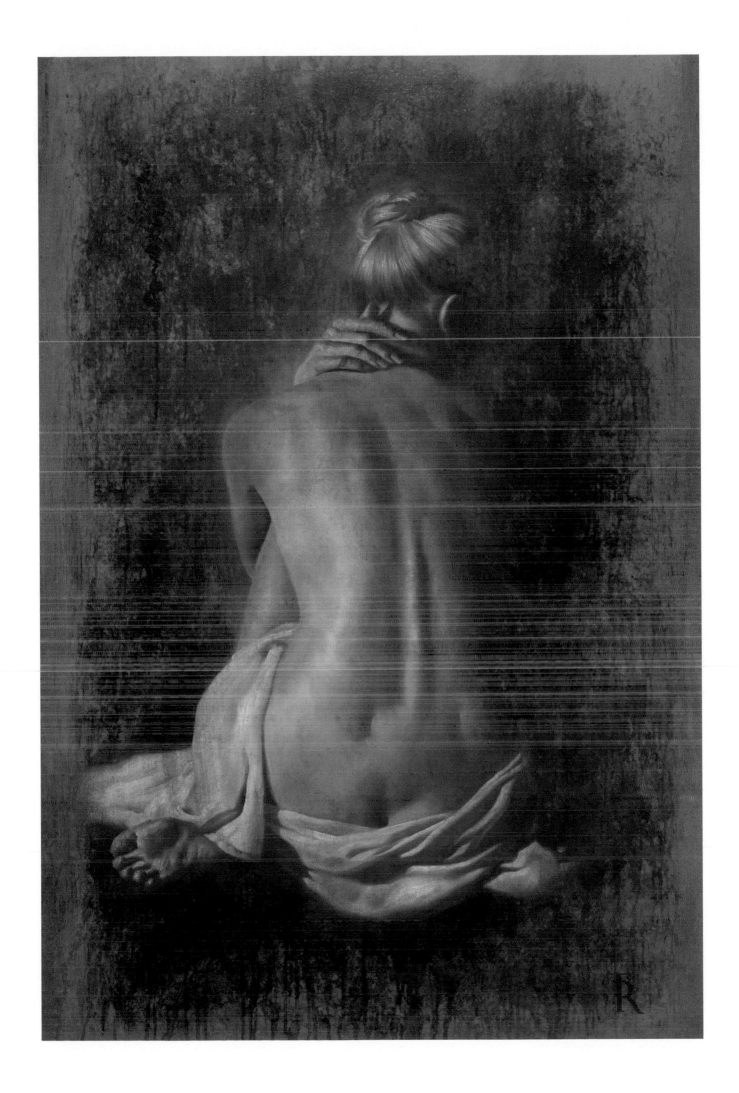

UMBROSA, 2005, OIL ON CANVAS, 31 X 49 IN.

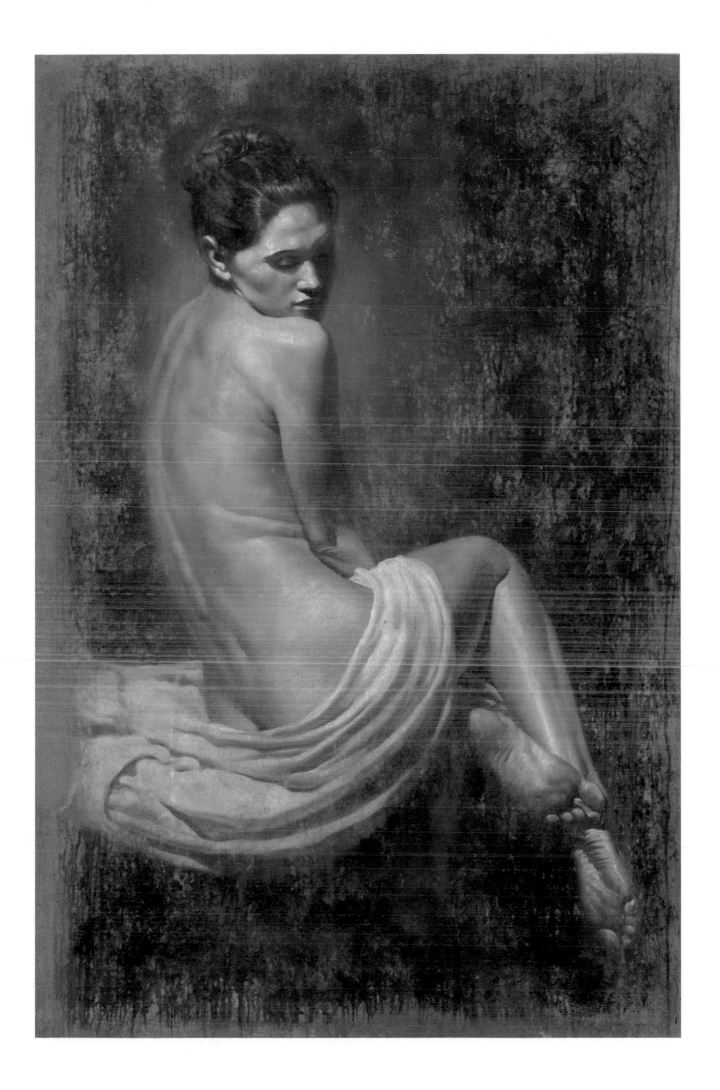